FIGURE PAINTING
Step by Step

Wendon Blake
Paintings by George Passantino

DOVER PUBLICATIONS, INC.
Mineola, New York

Bibliographical Note

This Dover edition, first published in 2000, is an abridged republication of the work originally published in 1980 by Watson-Guptill Publications, a division of Billboard Publications, as *Figures in Oil* (Part 3 of the author's *The Portrait and Figure Painting Book* in the series The Artist's Painting Library). The Dover edition includes 57 full-color reproductions of paintings and 60 black-and-white reproductions of drawings and paintings by George Passantino, as well as four other black-and-white illustrations.

Library of Congress Cataloging-in-Publication Data

Blake, Wendon.
 [Figures in oil]
 Figure painting step by step / Wendon Blake ; paintings by George Passantino.—Dover ed.
 p. cm.
 Originally published: Figures in oil. New York : Watson-Guptill Publications, 1980, in series: The artist's painting library.
 ISBN 0-486-41470-1 (pbk.)
 1. Female nude in art. 2. Figure painting—Technique. I. Passantino, George. II. Title.

ND1290.7 .B56 2000
751.45'424—dc21

00-043123

Manufactured in the United States of America
Dover Publications, Inc., 31 East 2nd Street, Mineola, N.Y. 11501

CONTENTS

Figure Painting in Oil. From the beginning of time, artists have painted and sculpted the nude female figure with unending fascination. Famous nudes have been painted of goddesses, wives, lovers, friends, and professional models. Whoever the model might be, the artist regards the nude figure as something sacred—the nude is the vehicle through which artists express their ideal of beauty. Thus, it's not surprising that men and women are equally hypnotized by the great nudes in the world's museums. Nor is it surprising that many of the finest nudes of this century have been painted by women.

Learning About the Figure. In the next few pages, you'll study a series of step-by-step demonstrations in which George Passantino, a noted American painter who's a master of the figure, shows you how to paint the basic forms of the body. First, Passantino shows you the steps in painting a woman's head, beginning with the preliminary brush drawing, continuing through the gradual buildup of the lights and shadows, and concluding with the final details of the head. Then Passantino goes on to paint three views of the torso, step by step, showing you how to visualize the torso from the front, in three-quarter view, and finally from the back. He concludes by demonstrating the steps in painting the arm and the leg. These demonstrations are all in black and white oil paint: the artist simply blends black and white paint on his palette to produce a variety of grays. Before beginning to work in color, it's worthwhile to try this yourself. Paint a series of figure studies in black and white to learn how the shapes of the figure are revealed by the play of light and shadow over the form. This is very much like "drawing" in oil paint as preliminary practice for working in color.

Color Demonstrations. Next, George Passantino paints a series of seven nudes in color, exploring seven different poses and views of the female figure. You'll also find a variety of indoor and outdoor lighting effects and various combinations of skin and hair colors. The first demonstration is the easiest: a front view of a seated figure in subdued, indoor lighting, with a very simple pattern of lights and shadows. This is followed by a back view of a seated figure indoors; a front view of a standing figure in warm, atmospheric, indoor light; a three-quarter view of a seated figure indoors; a back view of a standing figure in a landscape setting; a front view of a reclining figure indoors, with most of the form in shadow; and finally a back view of a reclining figure indoors. Hair colors range from blond to brown to black, while skin tones vary from pale pink to olive. You'll find detailed instructions for mixing all these different hues—and you'll see how these colors are influenced by both natural and artificial light.

Proportions, Lighting, Drawing. In painting the nude, it's particularly important to master the proportions of an "ideal" female figure. Even though models will vary considerably in their proportions, these "ideal" proportions are helpful guidelines. So the color demonstrations are followed by a series of oil sketches that analyze the proportions of a standing female figure seen from the front, from the side, in three-quarter view, and from the back. Then you'll find oil sketches of different kinds of lighting that are particularly effective in figure painting. Since figure drawing is essential practice for figure painting—and a great pleasure in itself—Passantino demonstrates how to draw the figure in pencil, charcoal, and chalk. Then he concludes with a demonstration that shows you how to make a black-and-white oil sketch as an end in itself *or* as a study for an oil painting.

Finding Models. As most artists and art students have discovered, people aren't nearly as shy as they used to be. Wives, girl friends, and acquaintances are accustomed to today's revealing beachwear and resort fashions, so they're often flattered by an invitation to pose for a painting. If you prefer to paint a professional model, check your nearest art school, college, or university to see whether they've got a so-called *life class* which you can join. It's common for a school to hire a professional model and provide a studio in which a group of students or serious amateurs can paint for several hours, merely paying a modest admission fee. You can also form your own life class with five or six friends, working in someone's home and sharing the cost of the model among you. To find a professional model for your own life class, you might call your local art school, college, or university to find out where they get their models. Professional artists often find excellent models by contacting dance or drama schools, whose students are willing to model part time in order to finance their professional training for the theater. The important thing is to work from the living figure—not from photographs—and to paint and draw as often as you can. If you join a life class—or form your own—make a habit of going at least once a week. When you go to the beach, take your sketchpad! Never miss an opportunity to draw that miraculous creation, the human figure.

Color Selection. For mixing flesh and hair tones, portrait and figure painters lean heavily on warm colors—colors in the red, yellow, orange, and brown range. As you'll see in a moment, these colors dominate the palette. However, even with a very full selection of these warm colors, the palette rarely includes more than a dozen hues.

Reds. Cadmium red light is a fiery red with a hint of orange. It has tremendous tinting strength, which means that just a little goes a long way when you mix cadmium red with another color. Alizarin crimson is a darker red with a slightly violet cast. Venetian red is a coppery, brownish hue with considerable tinting strength too. Venetian red is a member of a whole family of coppery tones which include Indian red, English red, light red, and terra rosa. Any one of these will do.

Yellows. Cadmium yellow light is a dazzling, sunny yellow with tremendous tinting strength, like all the cadmiums. Yellow ochre is a soft, tannish tone. Raw sienna is a dark, yellowish brown as it comes from the tube, but turns to a tannish yellow when you add white—with a slightly more golden tone than yellow ochre. Thus, yellow ochre and raw sienna perform similar functions. Choose either one.

Cadmium Orange. You can easily mix cadmium orange by blending cadmium red light and cadmium yellow light. So cadmium orange is really an optional color—though it's convenient to have.

Browns. Burnt umber is a rich, deep brown. Raw umber is a subdued, dusty brown that turns to a kind of golden gray when you add white.

Blues. Ultramarine blue is a dark, subdued hue with a faint hint of violet. Cobalt blue is bright and delicate.

Green. Knowing that they can easily mix a wide range of greens by mixing the various blues and yellows on their palettes, many professionals don't bother to carry green. However, it's convenient to have a tube of green handy. The bright, clear hue called viridian is the green that most painters choose.

Black and White. The standard black, used by almost every oil painter, is ivory black. Buy either zinc white or titanium white; there's very little difference between them except for their chemical content. Be sure to buy the biggest tube of white that's sold in the store; you'll use lots of it.

Linseed Oil. Although the color in the tubes already contains linseed oil, the manufacturer adds only enough oil to produce a thick paste that you squeeze out in little mounds around the edge of your palette. When you start to paint, you'll probably prefer more fluid color. So buy a bottle of linseed oil and pour some into that little metal cup (or "dipper") clipped to the edge of your palette. You can then dip your brush into the oil, pick up some paint on the tip of the brush, and blend oil and paint together on your palette.

Turpentine. Buy a big bottle of turpentine for two purposes. You'll want to fill that second metal cup, clipped to the edge of your palette, so that you can add a few drops of turpentine to the mixture of paint and linseed oil. This will make the paint even more fluid. The more turpentine you add, the more liquid the paint will become. Some oil painters like to premix linseed oil and turpentine, 50-50, in a bottle to make a thinner *painting medium*, as it's called. They keep the medium in one palette cup and pure turpentine in the other. For cleaning your brushes as you paint, pour some more turpentine into a jar about the size of your hand and keep this jar near the palette. Then, when you want to rinse out the color on your brush and pick up a fresh color, you simply swirl the brush around in the turpentine and wipe the bristles on a newspaper.

Painting Mediums. The simplest painting medium is the traditional 50-50 blend of linseed oil and turpentine. Many painters are satisfied to thin their paint with that medium for the rest of their lives. On the other hand, art supply stores do sell other mediums that you might like to try. Three of the most popular are damar, copal, and mastic painting mediums. These are usually a blend of natural resin—called damar, copal, or mastic, as you might expect—plus some linseed oil and some turpentine. The resin is really a kind of varnish that adds luminosity to the paint and makes it dry more quickly. Once you've tried the traditional linseed oil–turpentine combination, you might like to experiment with one of these resinous mediums. You might also like to try a gel medium. This is a clear paste that comes in a tube.

Palette Layout. Before you start to paint, squeeze out a little dab of each color on your palette, plus a *big* dab of white. Establish a fixed location for each color, so you can find it easily. One good way is to place your *cool* colors (black, blue, green) along one edge and the *warm* colors (yellow, orange, red, brown) along another edge. Put the white in a corner where it won't be soiled by the other colors.

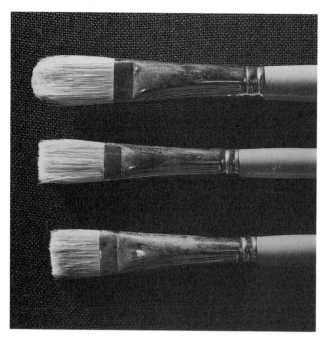

Bristle Brushes. The filbert (top) is long and springy, comes to a rounded tip, and makes a soft stroke. The flat (center) has a squarish tip and makes a more rectangular stroke. The bright (bottom) also makes a rectangular stroke, but the bristles are short and stiff, leaving a strongly textured stroke.

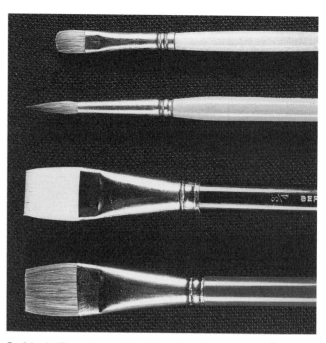

Softhair Brushes. Bristle brushes do most of the work, but softhair brushes are helpful for smoother, more precise brushwork. The top two are sables: a small, flat brush that makes rectangular strokes; a round, pointed brush that makes fluid lines. At the bottom is an oxhair brush, while just above it is a soft, white nylon brush; both make broad, smooth, squarish strokes.

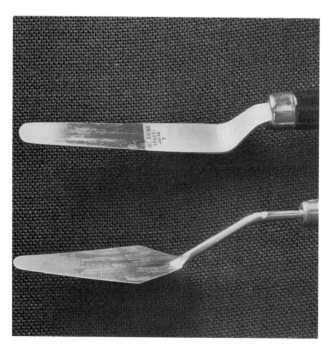

Knives. A palette knife (top) is useful for mixing color on the palette; for scraping color off the palette at the end of the painting session; and for scraping color off the canvas when you're dissatisfied with what you've done and want to make a fresh start. A painting knife (bottom) has a very thin, flexible blade that's specially designed for spreading color on canvas.

Easel. A wooden studio easel is convenient. Your canvas board, stretched canvas, or gesso panel is held upright by wooden "grippers" that slide up and down to fit the size of the painting. They also adjust to match your own height. Buy the heaviest and sturdiest you can afford, so it won't wobble when you attack the painting with vigorous strokes.

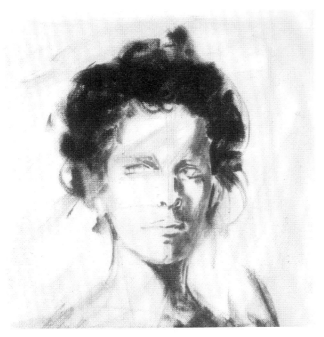

Step 1. A round softhair brush draws the contours of the head and features. Then a bristle brush places the darks on the hair, face, neck, and shoulder, also indicating the darks within the features.

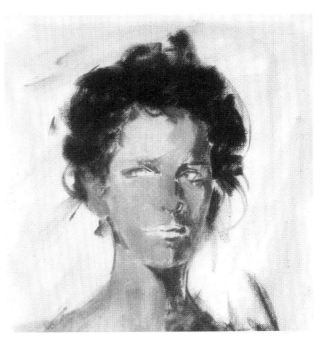

Step 2. A bristle brush covers the lighted side of the face and the lighted sides of the features with a pale tone. This tone is carried downward over the lighted areas of the neck and shoulder.

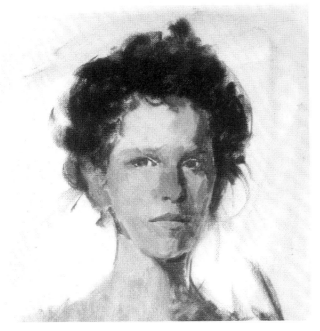

Step 3. Halftones are paler than shadows, but darker than the light areas. Now these halftones are placed in the eye-sockets, on the nose, and where the lights and shadows meet on the forehead, cheek, and chin.

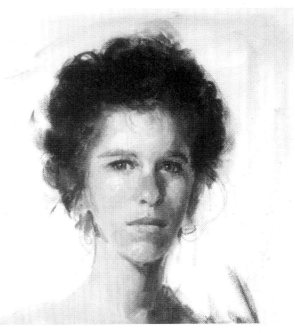

Step 4. A flat brush—either bristle or softhair—brushes the lights, halftones, and shadows softly together. A bristle brush strengthens the lights and blends these touches of light into the surrounding tones. A small brush adds the details of the features.

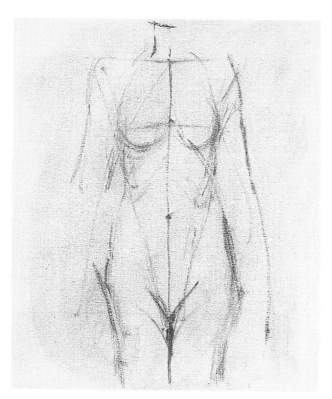

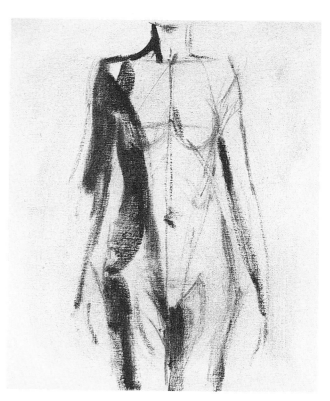

Step 1. A round brush sketches the shapes. A vertical center line aids symmetry; horizontal lines locate the shoulders and the centers of the breasts; diagonals show the alignment of the shoulders, waist, and crotch.

Step 2. A bristle brush covers the shadow side of the figure with broad strokes of dark color. These darks appear not only on the outer edge of the torso, but on such smaller forms as the breasts and abdomen.

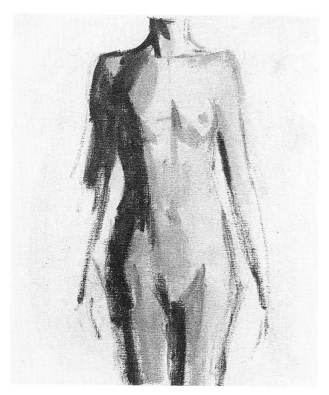

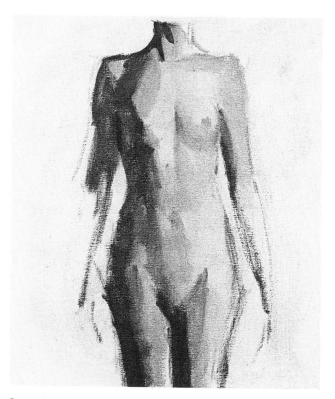

Step 3. A big bristle brush covers the lighted areas of the torso with pale color, obliterating the guidelines that still remain visible in Step 2.

Step 4. A bristle brush adds the halftones where the light and shadow meet. These are most visible in the area of the waist, hip, and thigh. A halftone is carried down the side of the abdomen.

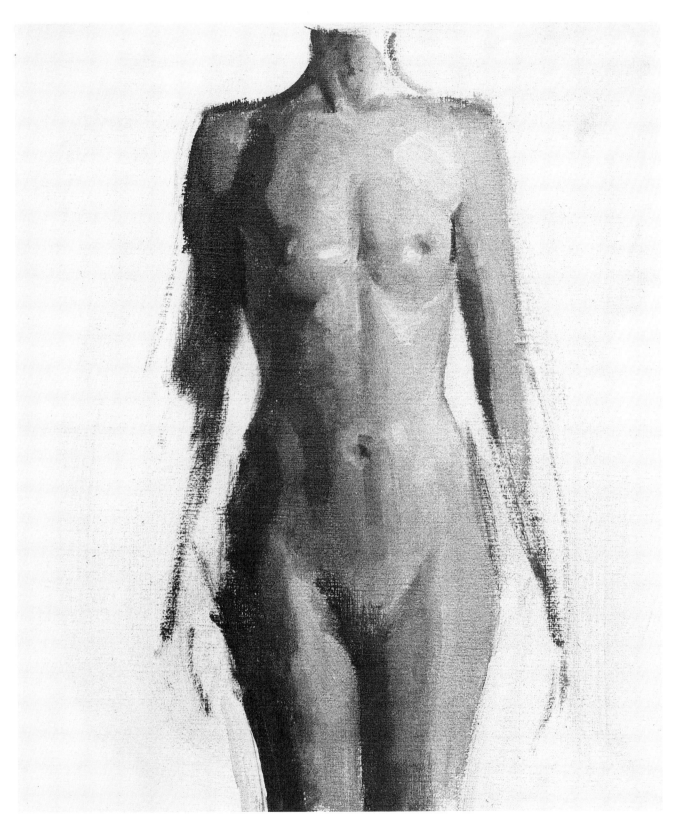

Step 5. A flat brush blends the meeting places of the lights, halftones, and shadows on the dark side of the figure. The shadows are darkened and blended to produce a smoother tone. The lighted areas are strengthened on the chest, breasts, ribs, and abdomen—and these pale strokes are blended softly into the surrounding skin tone. Notice how the shadow has been deepened on the dark skin of the abdomen. A small brush places the last touches, darkening the nipples, the division between the breasts, the navel, and the valley that runs down the center of the torso—also adding highlights to the breasts, rib area, and navel.

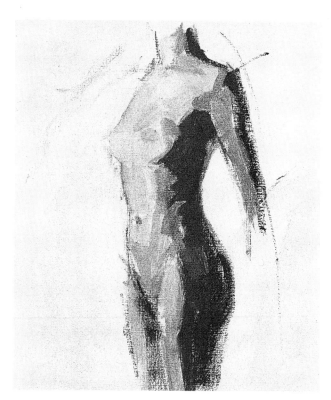

Step 1. A round brush draws the contours. As the figure turns, the vertical center line follows the convex curve of the body. Other curving guidelines visualize the upper and lower torso as egg shapes.

Step 2. A big bristle brush covers the shadow side of the torso with a single mass of dark color, repeating this tone on the shadow sides of the neck, shoulder, and arm.

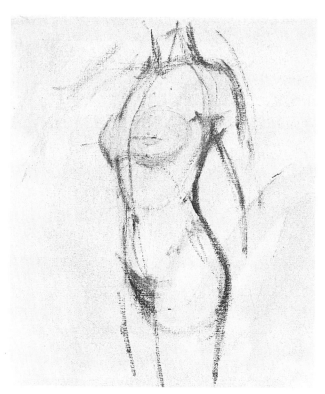

Step 3. A large bristle brush covers the lighted front of the torso with a pale tone. Then the brush blocks in the halftones that fall between the light and shadow areas.

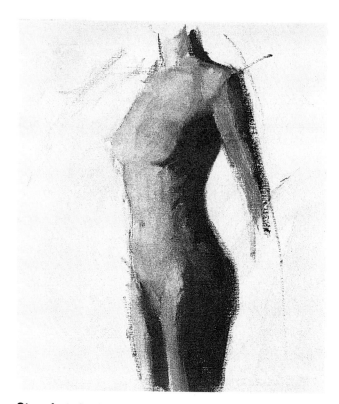

Step 4. A flat brush begins to blend the lights, halftones, and shadows into smoother, more continuous tones. Now the figure looks softer and rounder.

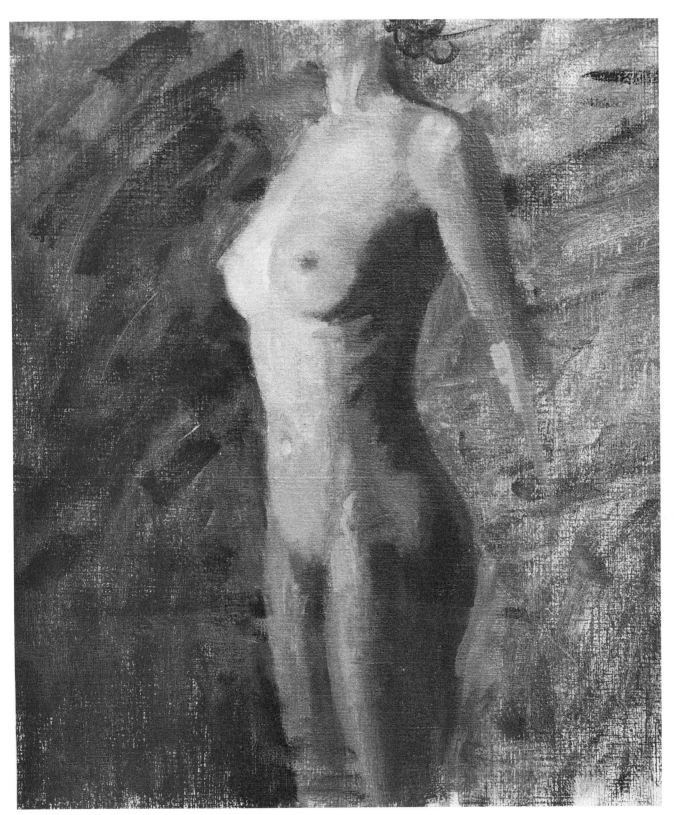

Step 5. A flat brush strengthens the lighted areas on the chest, breast, rib cage, abdomen, and thighs. To accentuate the lighted planes of the figure, the background is darkened at the left. The shadow side of the figure is also strengthened—note that the background is paler on this side. The brush continues to blend the meeting places of light, shadow, and halftone—compare the thighs in Step 4 and Step 5 to see how this blending makes the forms look rounder and more lifelike. A small brush adds such finishing touches as the nipples and ribs.

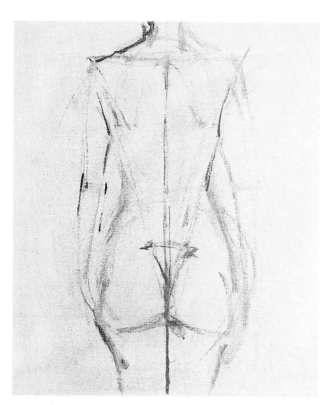

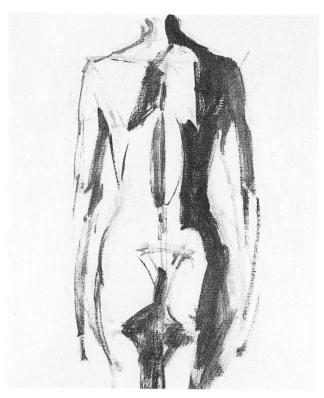

Step 1. The contours of the figure are drawn with the tip of a round softhair brush. A vertical center line aids symmetry, while other guidelines emphasize the diamond shape of the back.

Step 2. A big, flat brush covers the shadow side of the figure with broad strokes. Darks also appear on the shoulderblade, in the valley of the spine, and between the buttocks.

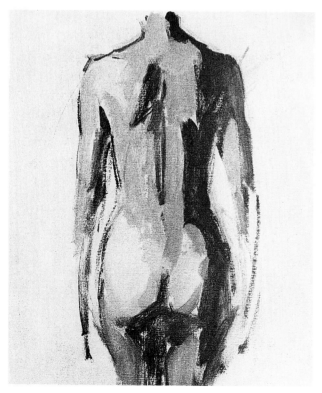

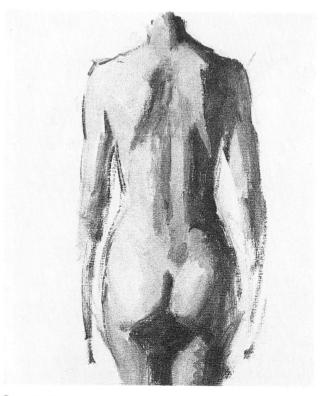

Step 3. A large, flat brush covers the lighted areas of the torso. The buttocks are paler because they project outward into the light.

Step 4. Halftones are placed between the lights and shadows. You can see these most clearly on the lower back and the buttocks. The brush begins to blend the lights, halftones, and shadows.

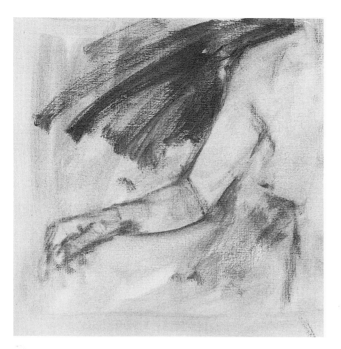

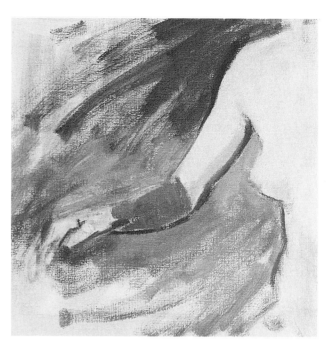

Step 1. The tip of a round brush draws the shapes of the upper arm, forearm, and hand. A diagonal guideline indicates the meeting place of the upper arm and the forearm, where a shadow will begin. A second, smaller guideline indicates the end of that shadow on the wrist.

Step 2. A small bristle brush carries a dark line of shadow along the undersides of the upper arm and the forearm. A bigger bristle brush blocks in the light and halftone on the upper arm; the shadow on the side of the forearm; and the lighted areas of the hand.

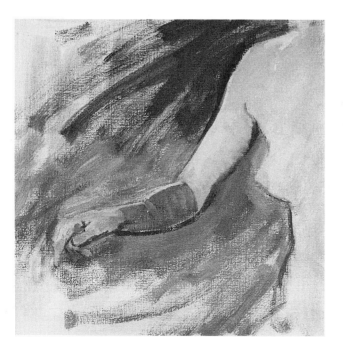

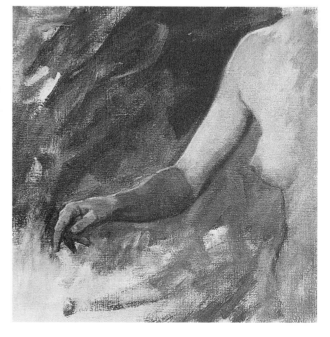

Step 3. A flat brush darkens and blends the underside of the upper arm; darkens the shadow on the forearm and adds some pale strokes to suggest reflected light within the shadow; then blends the tones on the forearm. A round brush defines the lighted edge of the forearm and defines the shapes of the hand—brightening the lighted tops of the forms and darkening the shadowy undersides.

Step 4. The tones of the upper arm are smoothly blended by a flat brush. A round brush sharpens the lighted edge of the forearm, which is now a single bright line. The shadow side of the forearm is darkened and blended; it's really like a very dark halftone, curving around to a line of deep shadow below. The round brush paints the lights, halftones, and shadows on the hand.

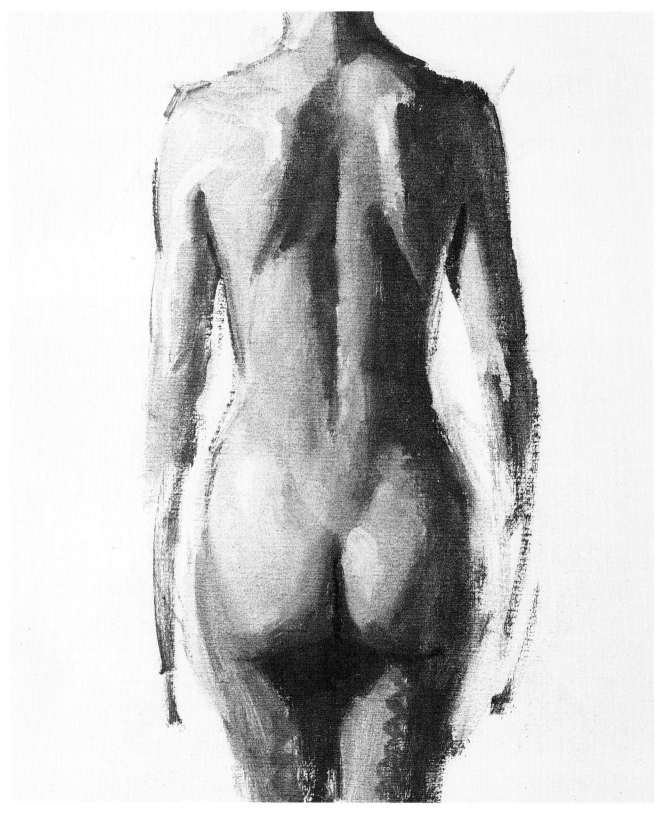

Step 5. A flat brush blends the lights, halftones, and shadows, which now fuse into smooth, continuous tones. The lights are built up selectively on the shoulderblades and the buttocks. The darks are also strengthened—particularly on the shoulderblades, in the valley of the spine, and beneath the buttocks. A small round brush adds the last few details, such as the dark line of the spine between the shoulderblades; the shadow line in the armpits; and the dark line between the buttocks.

Step 1. A round brush draws the contours of the upper and lower legs and the feet. The feet are drawn as simple shapes—ignoring the details of the toes.

Step 2. A large bristle brush paints the shadow sides of the forms in broad, flat tones. A few strokes of dark background are added. These dark strokes make it easier to visualize just how dark to make the shadow sides of the forms.

Step 3. The lighted planes of the lower legs are painted in flat tones. The background is also covered with tone to make it easier to visualize the correct distribution of tones on the legs. A few strokes darken the calf of the near leg.

Step 4. A flat brush blends the light and dark areas of the legs. There's now a subtle gradation from dark to light on the calves, which are dark just below the knees and grow lighter toward the ankles. A small bristle brush paints the shadows on the feet; then the tip of a round brush adds the final details of the heels and toes.

Buying Brushes. There are three rules for buying brushes. Buy the best you can afford—even if you can afford only a few. Buy big brushes, not little ones; big brushes encourage you to work in bold strokes. And buy brushes in pairs, roughly the same size. For example, if you're painting the light and shadow planes of a face, you can use one big brush for the shadows, but you'll want another big brush, unsullied by dark colors, to paint the skin in bright light.

Recommended Brushes. Begin with a couple of really big bristle brushes, around 1″ (25 mm) wide for painting your largest color area. Try two different shapes: possibly a flat and a filbert, one smaller than the other. Then you'll need two or three bristle brushes about half this size; again, try a flat, a filbert, and perhaps a bright. For painting smoother passages, details, and lines, three softhair brushes are useful: one that's about 1/2″ (12.5 mm) wide; one that's about half this wide; and a pointed, round brush that's about 1/8″ or 3/16″ (3–5 mm) thick at the widest point.

Knives. For mixing colors on the palette and for scraping a wet canvas when you want to make a correction, a palette knife is essential. Many oil painters prefer to mix colors with the knife. If you like to *paint* with a knife, buy a painting knife with a short, flexible, diamond-shaped blade.

Painting Surfaces. When you're starting to paint in oil, you can buy inexpensive canvas boards at any art supply store. These are canvas coated with white paint and glued to sturdy cardboard in standard sizes that will fit into your paintbox. Another pleasant, inexpensive painting surface is canvas-textured paper that you can buy in pads, just like drawing paper. (Many of the demonstrations in this book are painted on canvas-textured paper.) Later, you can buy stretched canvas—sheets of canvas, precoated with white paint and nailed to a rectangular frame made of wooden stretcher bars. You can save money if you buy stretcher bars and canvas, then assemble them yourself. If you like to paint on a smooth surface, buy sheets of hardboard and coat them with acrylic gesso, a thick, white paint that you can thin with water.

Easel. An easel is helpful, but not essential. It's just a wooden framework with two "grippers" that hold the canvas upright while you paint. The "grippers" slide up and down to fit larger or smaller paintings—and to match your height. If you'd rather not invest in an easel, you can improvise. One way is to buy a sheet of fiberboard about 1″ (25 mm) thick and hammer a few nails part way into the board, so the heads of the nails overlap the edges of the painting and hold it securely.

Prop the board upright on a tabletop or a chair. Or you can just tack canvas-textured paper to the fiberboard.

Paintbox. To store your painting equipment and to carry your gear from place to place, a wooden paintbox is convenient. The box has compartments for brushes, knives, tubes, small bottles of oil and turpentine, and other accessories. It usually holds a palette—plus canvas boards inside the lid.

Palette. A wooden paintbox often comes with a wooden palette. Rub the palette with several coats of linseed oil to make the surface smooth, shiny, and nonabsorbent. When the oil is dry, the palette won't soak up your tube color and will be easy to clean at the end of the painting day. Even more convenient is a paper palette. This looks like a sketchpad, but the pages are nonabsorbent paper. You squeeze out your colors on the top sheet. When you're finished, you just tear off and discard the top sheet. Paper palettes come in standard sizes that fit into your paintbox.

Odds and Ends. To hold turpentine, linseed oil, or painting medium, buy two metal palette cups (or "dippers"). Make a habit of collecting absorbent, lint-free rags to wipe mistakes off your painting. Paper towels or old newspapers (a lot cheaper than paper towels) are essential for wiping your brush after rinsing in turpentine.

Furniture. Be sure to have a comfortable chair or couch for your model. Not many people have the stamina to *stand* for hours while they're being painted! If you're working at an easel, you're probably standing while the model sits or sprawls—which means that the model is below your eye level. That's why professional portrait and figure painters generally have a model stand. This is just a sturdy wooden platform or box about as high as your knee and big enough to accommodate a large chair or even a small couch. If you're handy with tools, you can build it yourself. (Of course, you can always work sitting down!) Another useful piece of equipment is a folding screen on which you can hang pieces of colored cloth—which can be nothing more than old blankets—to create different background tones.

Lighting. If your studio or workroom has big windows or a skylight, that may be all the light you need. Most professionals really prefer natural light. If you need to boost the natural light in the room, don't buy photographic floodlights; they're too hot and produce too much glare. Ordinary floor lamps, tabletop lamps, or those hinged lamps used by architects will give you softer, more "natural" light. If you have fluorescent lights, make sure that the tubes are "warm white."

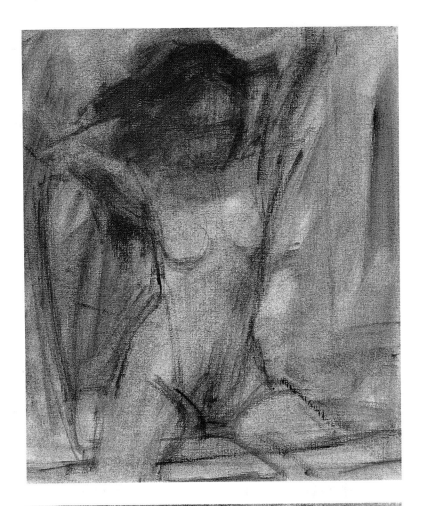

Step 1. A seated pose is easy for the model to hold, and a front view is easy to paint—so this is a good subject for your first figure painting. A rag tones the canvas with ultramarine blue, burnt umber, and turpentine. More burnt umber is blended into this mixture for the preliminary brush drawing, which is executed with a round softhair brush. The purpose of the brush drawing is to define the shapes of the figure with a few simple lines. A rag wipes away the lighted areas of the torso, and then a bristle brush indicates the shadow tones on the face and chest, under the arms, on one side of the torso, and on the abdomen. A darker tone is scrubbed over the hair. Notice the horizontal guideline that aids the artist in aligning the shoulders. Within the face, a dark, horizontal stroke suggests the placement of the shadowy eye sockets.

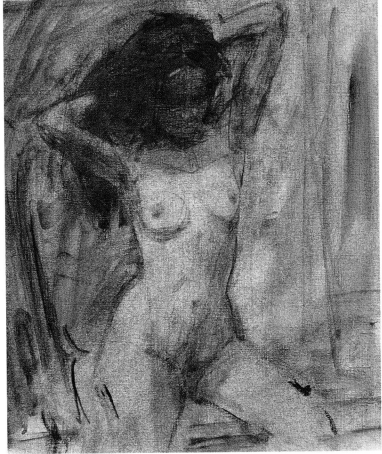

Step 2. The shape of the hair is more sharply defined with dark strokes. Then the brush moves downward to darken the eye sockets and sharpen the curve of the chin by placing a shadow beneath. The shapes of the arms are more carefully defined with slender strokes. A rag wipes away unnecessary strokes within the torso and thighs. Then the tip of the round brush strengthens the outer contours of the torso, shapes the breasts, and places the nipples and navel. The shadows on the torso are darkened with a flat brush. More strokes darken the background, and the sketch is completed.

Step 3. A bristle brush blocks in the shadows with rough strokes of raw sienna, Venetian red, a little ultramarine blue, and white. This tone is carried up over the face. It's important to work on the background as the figure progresses, so a big bristle brush places some background color in the upper left—a mixture of ultramarine blue, burnt umber, a touch of Venetian red, and white. The paler background on the shadow side of the figure is suggested with white tinted with the darker background mixture. The warm tone of the cushion is suggested with a few strokes of ultramarine blue, alizarin crimson, and white. From this point on, all mixtures are diluted with painting medium.

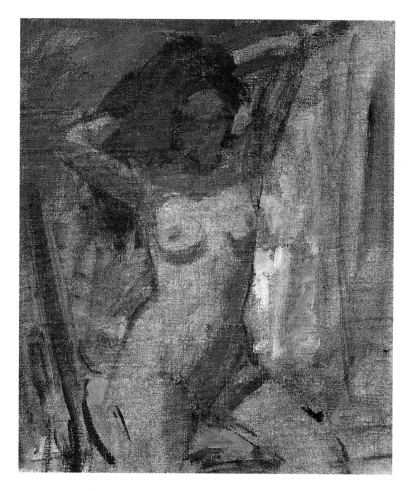

Step 4. A big bristle brush blocks in the lighted areas of the figure with the same mixture—raw sienna, Venetian red, ultramarine blue, and much more white. Then an extra speck of ultramarine blue is added to the mixture to paint the halftones that appear under the breasts and on one side of the ribs. A paler, brighter version of the background color—burnt umber with more ultramarine blue and white—is brushed between the figure and the back of the chair.

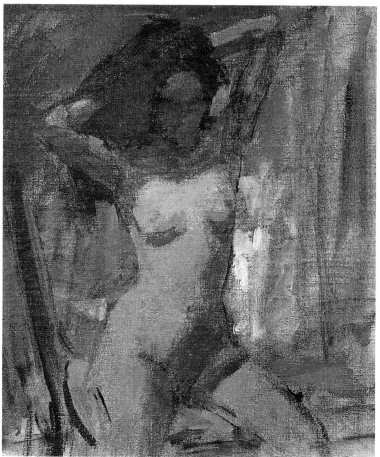

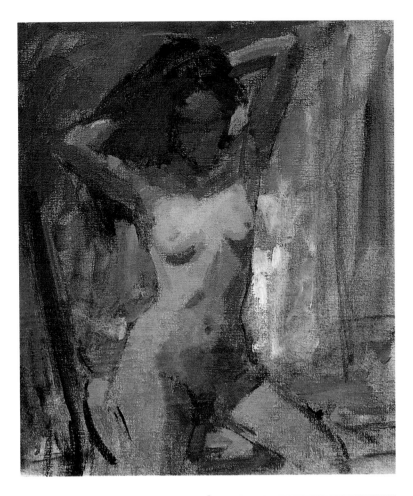

Step 5. The shadows beneath the arms are completed with the same shadow mixture used in Step 3. Then a large bristle brush completes the job of blocking in the halftones with a mixture of burnt umber, Venetian red, ultramarine blue, and white. Working downward from the top of the figure, the brush places the halftones next to the shadows on the arms, chest, breasts, midriff, abdomen, and thighs. Then the shadows are darkened with the same mixture strengthened with a bit more burnt umber and ultramarine blue. You can now see distinct masses of light, halftone, and shadow on the torso.

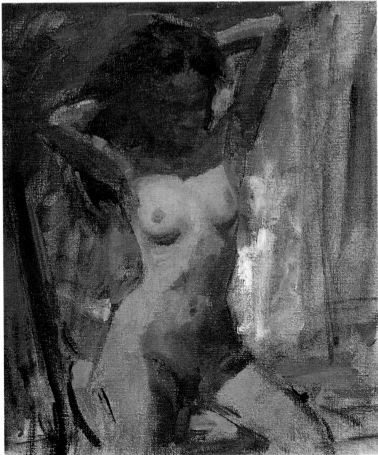

Step 6. Although the face is in shadow, there are still subdued patches of light, which a small bristle brush defines with burnt umber, Venetian red, ultramarine blue, and white. The same mixture with less white is used to paint the dark notes of the features. The light areas of the hair are suggested with a few strokes of the background mixture, which is the same combination of ultramarine blue, burnt umber, Venetian red, and white, but with more ultramarine blue. Then a flat brush begins to blend the lights, halftones, and shadows on the breasts, adding a touch of shadow beneath. For the color of the nipples the slightest touch of cadmium red is added to the halftone mixture.

Step 7. Continuing to work downward, a flat brush begins to blend the lights, halftones, and shadows on the midriff, abdomen, hips, and thighs. The lines of the original brush drawing have almost completely disappeared by now. Notice how the shadow on the abdomen flows over the outstretched thigh in one continuous tone. The background tone is carried down to the bottom of the picture on the left, where the corner is warmed with an extra touch of burnt umber. This warm tone also modifies the lower corner at the right.

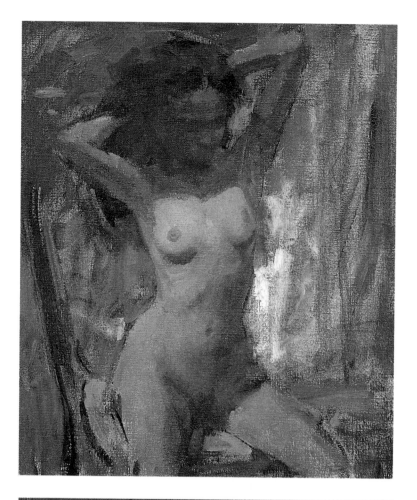

Step 8. A flat brush continues to blend the tones of the lower torso. Then a bit more white is blended into the shadow mixtures to lighten the face, making the cheeks, nose, and chin emerge from the shadow. A faint touch of cadmium red is added to this mixture for the lips. More white is added to the hair mixture, and then a round brush begins to pick out individual locks of hair. More white is added to the flesh mixture to strengthen the lighted areas of the torso and thighs.

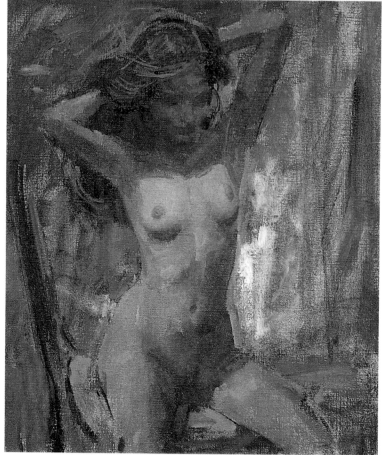

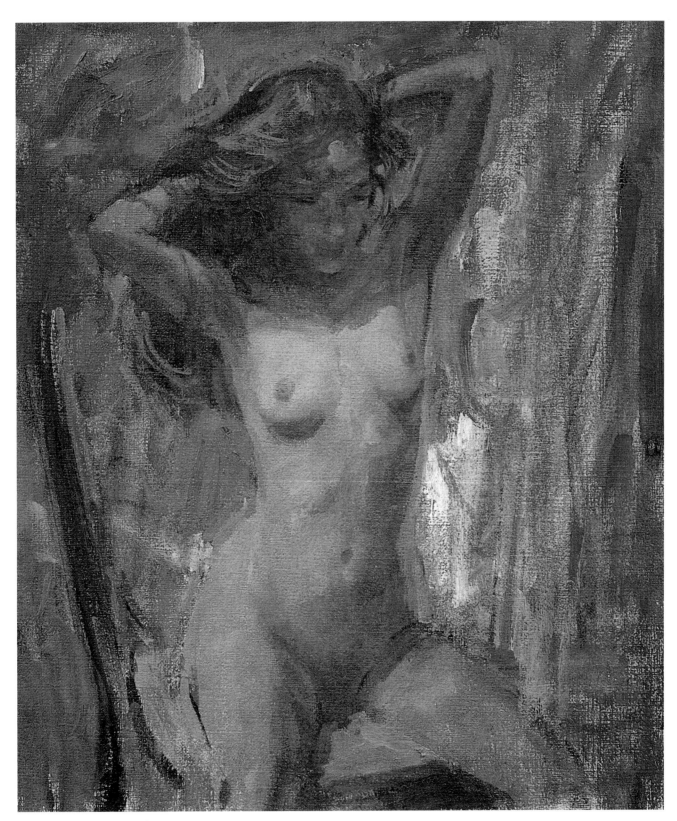

Step 9. A flat brush blends the lights, halftones, and shadows on the arms. The artist continues to build up and blend the lights on the midriff and abdomen. More white is blended into the cool background mixture, which is then carried carefully down the shadow side of the figure to define the curving shapes of the arms and torso more precisely. A few inconspicuous touches of this cool background mixture are blended into the shadows on the torso. A bristle brush blends the lighted area of the hair. Then a round brush picks out a few more locks of hair and uses the hair mixture to darken the eyes. The warm and cool colors of the background are roughly blended at the lower right. The background is completed with some thick strokes of rich, dark color above the head.

Step 1. The bare canvas is toned with a few broad brush strokes of raw umber, Venetian red, and turpentine. Then a round softhair brush draws the shape of the figure with this same mixture. A horizontal guideline establishes the alignment of the shoulders. A single curving line defines the spine, which also serves as a vertical center line which makes it easier to draw a symmetrical figure. Initially many of the lines are surprisingly straight; later on the contours of the figure will become rounded. A big flat brush covers the hair with a darker mixture of raw umber, Venetian red, and turpentine, and then begins to block in the dark tone of the background.

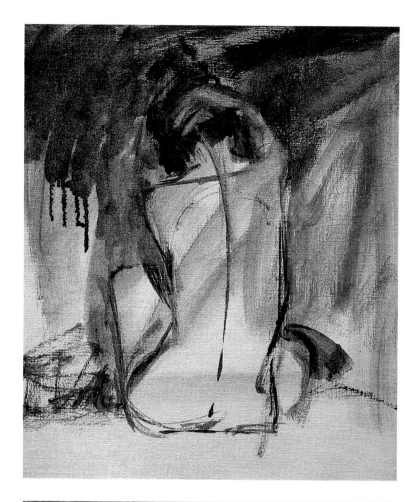

Step 2. A rag lightens the heavy lines that were drawn in Step 1. The tip of the brush redraws these contours more carefully, and then the dark background tone is carried down alongside the figure. The straight guideline for the shoulders is wiped away entirely. The dark strokes of the spine and buttocks are wiped down to pale lines. A flat bristle brush carries a broad plane of shadow down one side of the back, over the hip, and then over the upraised thigh. Paler shadows are also suggested on the dark sides of the thighs, on the arm and neck, and down the spine.

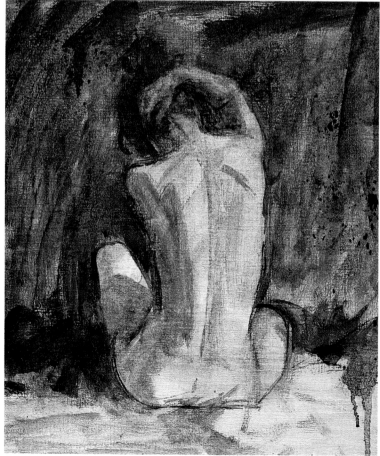

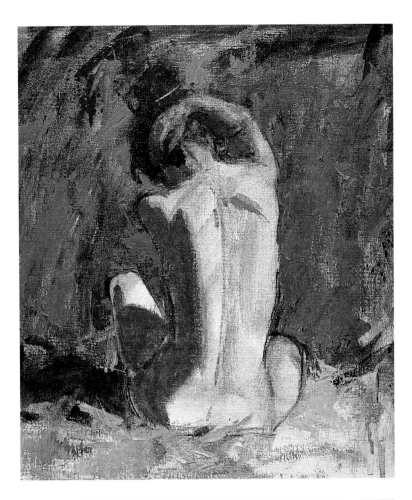

Step 3. A big bristle brush paints the solid tone of the shadow with raw umber, raw sienna, Venetian red, and white. This tone is placed not only on the back, hip, and thigh, but also on the shadow sides of the face, arm, and shoulder blade. The dark tone of the hair is reinforced with burnt umber, ultramarine blue, raw sienna, and a touch of white. The warm tone of the background is cooled with scrubby strokes of cobalt blue, cadmium red, and white—with more white at the left and more blue at the right. A paler version of this mixture suggests the fabric on which the model is seated.

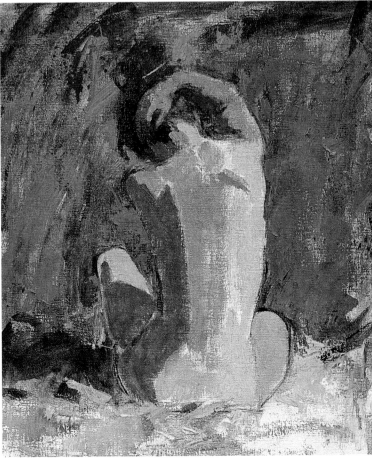

Step 4. A bristle brush covers the lighted side of the figure with a pale blend of raw umber, raw sienna, Venetian red, and plenty of white, making the mixture just a bit darker on the arm and thigh. The same mixture becomes just a bit darker—containing a little more raw umber—as the brush places the big patch of halftone down the center of the back between the light and shadow planes. This same halftone mixture is carried up the neck and along the arm. Most of the arm is now shadow and halftone, with just a small rim of light.

Step 5. A bristle brush carries the halftone farther down the back to the base of the spine and then up over the shoulder to the arm. The artist begins to blend the lights, halftones, and shadows where they meet on the back and neck. A little halftone mixture is brushed into the edge of the shadow side of the figure to make the dark tone more luminous and transparent. Farther in from the edge, the shadow tone is darkened with more raw umber. A dark line reinforces the spine. The lighted patches of hair are painted with touches of burnt umber, raw sienna, and white.

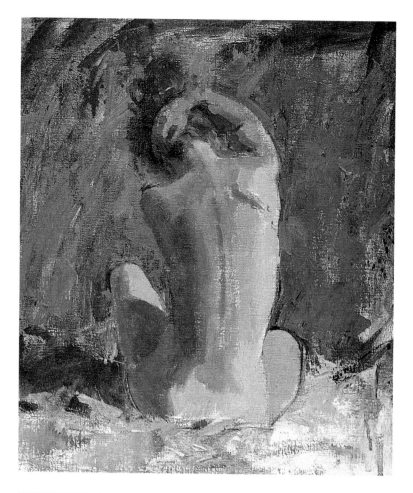

Step 6. A flat softhair brush moves over the entire back and thighs to soften and blend the meeting places of light, halftone, and shadow. Now the forms look smoother and rounder. The brush carefully retraces the curves of the lighted side of the back and then darkens the lighted thigh, which doesn't receive quite as much light as the back.

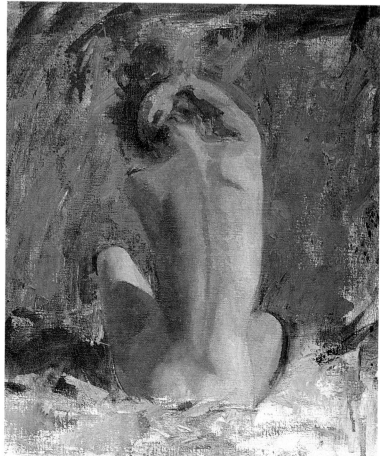

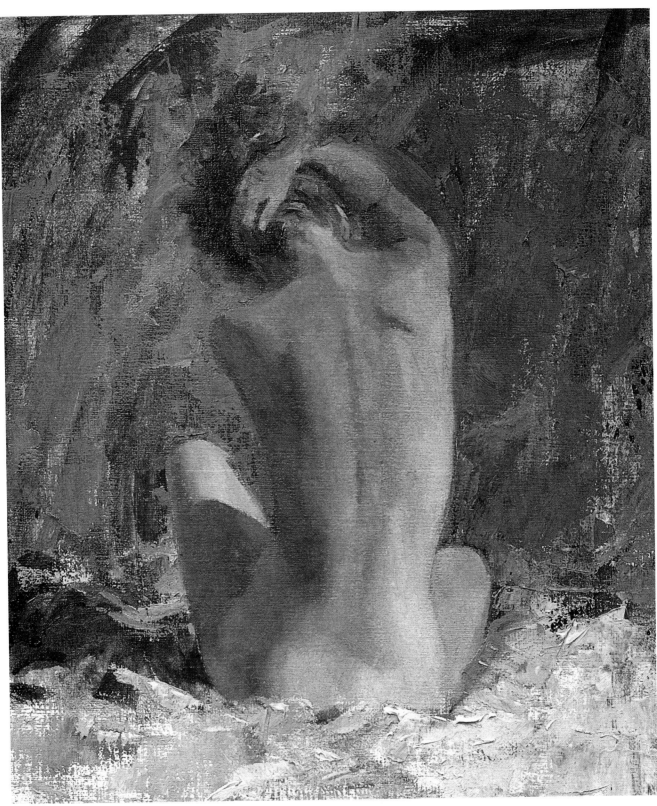

Step 7. A small, flat softhair brush blends the lights, shadows, and halftones on the upraised arm. Then the same brush blends a little more pale color into the lighted side of the figure, which now stands out more boldly against the darker background. The flexible blade of a painting knife places thick strokes of cobalt blue, cadmium red, and white on the foreground to suggest the soft fabric. The cast shadow at the left is the mixture that was originally placed there in Step 2—and left untouched. The red ribbon is a few quick strokes of cadmium red, alizarin crimson, a hint of cobalt blue, and white.

Step 1. A large bristle brush tones the background with raw sienna, burnt umber, a little cadmium orange, and turpentine. The top half of the canvas is darkened with more burnt umber. A round brush draws the contours of the figure with the same mixture, while a clean rag wipes away the lighted areas. More burnt umber is blended into the mixture to brush on the dark area of the hair. The face isn't wiped clean; some tone is left by the rag because the face is in shadow. The shadow tone is also carried over one shoulder and over the upper arm. The rest of the torso and the thighs are brightly lit—with few shadows—and these few darks are indicated with pale tones.

Step 2. The tip of the round brush carefully draws the shape of the figure with a darker version of the background tone. Features are suggested within the shadowy tone of the face. Small brushstrokes indicate the curly texture of the model's hair. A flat softhair brush and a rag work together—the brush adding subtle tones to the figure and the rag wiping away the lights. The sketch is completed.

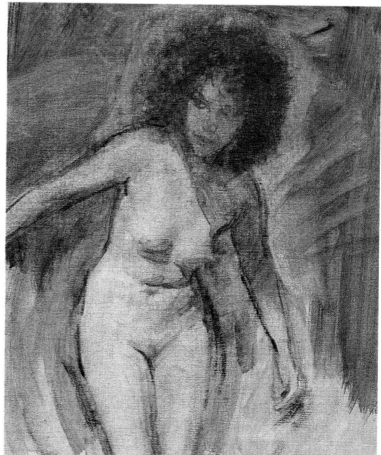

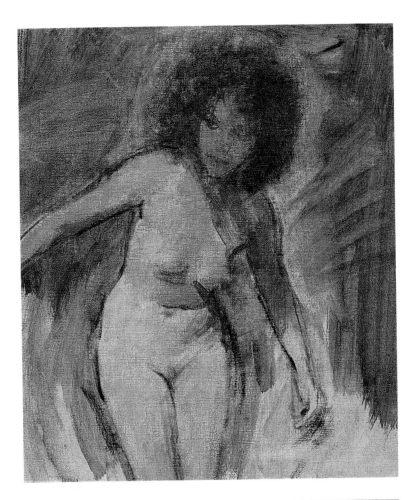

Step 3. The deep shadow on the chest, shoulder, and arm is darkened with burnt umber, raw sienna, cadmium orange, and white. Smaller strokes of this mixture indicate the shadow beneath the opposite arm and the shadow that runs from the midriff to the hips. The same color combination, but with much more white, is brushed over the lighted areas of the figure. Notice that the upraised arm, midriff, and thighs are just slightly darker than the chest and abdomen. A darker version of this flesh tone is brushed over the face. At this point all the work is done with bristle brushes.

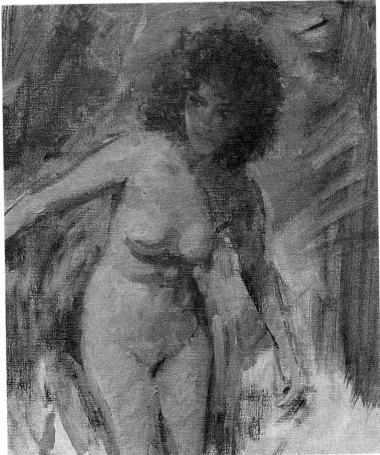

Step 4. There's so little difference between the lights and the halftones that the artist develops both at the same time. Working with a darker version of the pale skin mixture, one brush deepens the tones of the upraised arm, chest, midriff, abdomen, and thigh on the shadow side of the figure. At the same time another bristle brush blends more white into the skin mixture and builds up the lights on the upraised shoulder and the breasts; on the lighted areas of the midriff, abdomen, and thighs; as well as on the lighted wrist and hand of the opposite arm. The same combination of colors is used to paint the hair—with more burnt umber on the shadow side and more cadmium orange and white on the light side. The lighter hair tone is used to brighten the face; the eyes are added with the dark hair tone. The background is lightened around the head and darkened at the upper left.

Step 5. A flat softhair brush begins to blend the lights and halftones on the upper torso. The rough brushwork of Step 4 melts away into smooth tones. A warmer version of the shadow mixture—containing more cadmium orange—is blended into the dark area on the chest, shoulder, and upper arm. Some of this mixture is added to the underside of the breast to suggest reflected light. Then the shadows beneath the breasts are darkened with more burnt umber. The tip of the painting knife scratches away some wet color from the hair to indicate light falling on the curls.

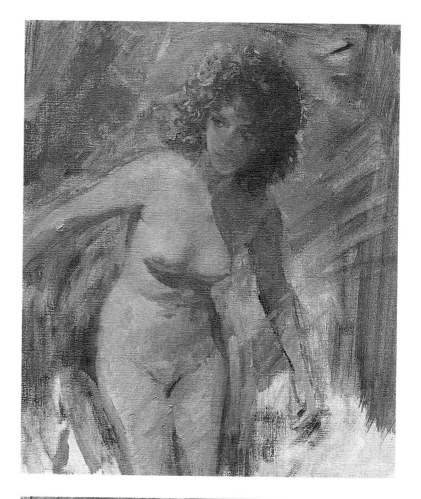

Step 6. The flat softhair brush continues to work down the figure, blending the tones of the lower torso and the thighs. Adding more white to the pale flesh tone, a small bristle brush builds up the lights on the brightly lit sides of one breast, the abdomen, and the hip. Adding still more cadmium orange and burnt umber to the shadow mixture, a small bristle brush deepens the shadows on the dark sides of the neck, midriff, and hips; crisp lines of the same mixture are added to the crease at the waist, the navel, and the dividing lines of the crotch and thighs. A little white is added to this mixture, which is then scrubbed around the hair.

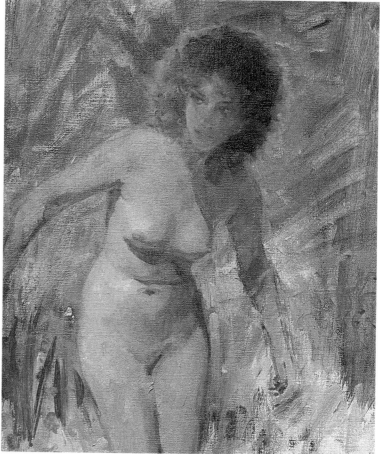

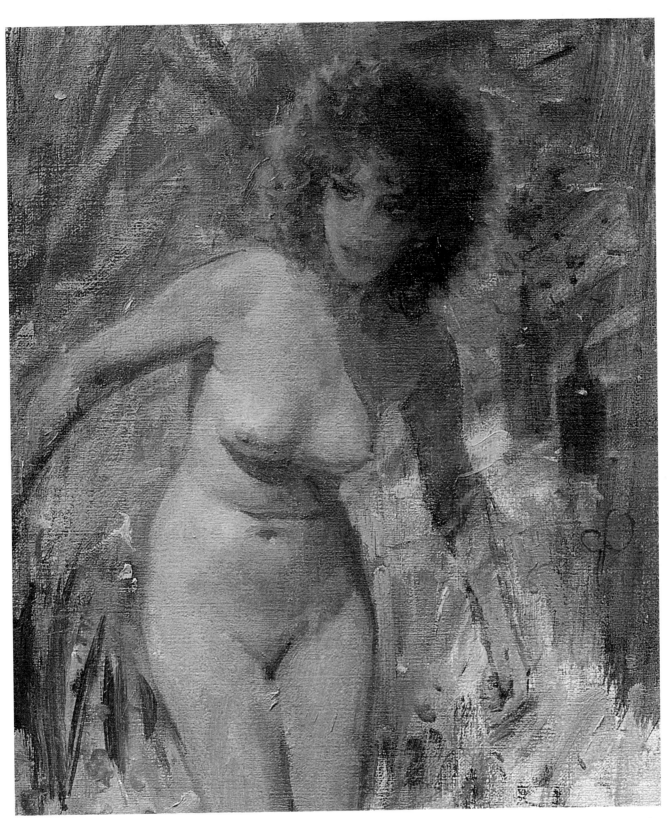

Step 7. The lights are built up on the upraised shoulder and along the upper edge of the arm. Touches of bright color enrich the shadow on the underside of that same arm, the lighted edges of the hair, the dark side of the cheek, the shadow beneath the chin, the shadows on the midriff and abdomen, and the upper half of the arm that's in shadow. Free strokes of this same bright mixture—still the same combination of cadmium orange, burnt umber, raw sienna, and a little white—animate the background to suggest the color of autumn foliage. For the bright touches of gold around the figure and in the lower right, cadmium yellow is substituted for raw sienna. The tip of a round brush adds the last few dark lines to sharpen the upraised shoulder, the features, the nipples, the side of the thigh that's in shadow, and the fingers. Tiny dabs of bright yellow suggest wildflowers.

Step 1. A wash of cobalt blue and turpentine is swept over the canvas by a big bristle brush. A darker tone of cobalt blue is scrubbed over the hair. Then a round brush begins the sketch with long, simple lines that capture the overall form and movement of the figure. A single curve defines the contour of the face, and two short lines are enough to suggest the neck. A horizontal stroke aligns the shoulders. Long, arc-like lines follow the contours of the arms, torso, and legs. A curving center line runs through the torso and helps locate the breasts, the waist, and the division between the legs.

Step 2. Darker strokes of cobalt blue, containing much less turpentine, cover the entire background. A clean rag wipes away the pale tone of the skin as the tip of a round brush sharpens the contours of the feet and indicates the details of the features, breasts, and hands. The figure is evenly lit and contains no strong areas of shadow.

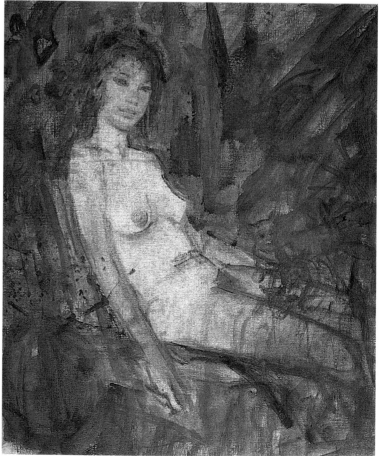

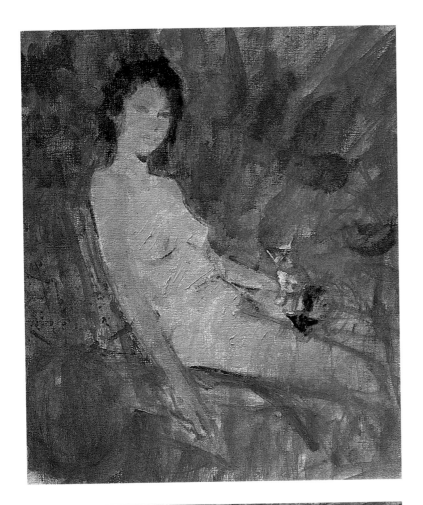

Step 3. A bristle brush covers the entire figure with a pale mixture of raw umber, raw sienna, a little Venetian red, and white. Because there are no strong shadows, the artist pays careful attention to very slight variations in tone. The cheeks, nose, arms, and thigh are slightly darker than the torso. A hint of shadow appears on the breast and on one side of the midriff and hips. A much darker version of the same mixture—containing less white and more Venetian red—is brushed over the upper background. The dark shape of the hair is blocked in with burnt umber and ultramarine blue. A small brush sketches in the kittens on the model's lap with the dark hair mixture repeated on one kitten, the warm background tone repeated on the other.

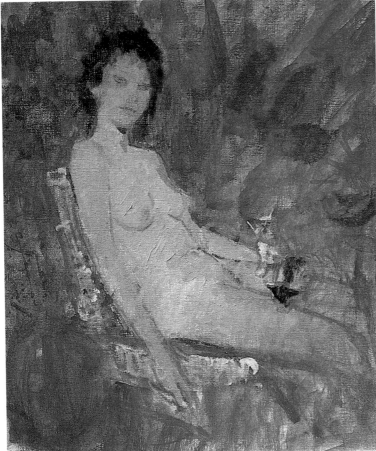

Step 4. Still searching for the subtle color variations, a small brush deepens the flesh mixture with a little more raw umber and Venetian red and adds dark touches to the chin, neck, shoulders, arms, breasts, and midriff. Still more Venetian red and raw sienna are added to the mixture to enrich the tones of the face, nipples, and thighs. A little cadmium red is added to this mixture for the lips.

Step 5. Darkening the flesh mixture with more raw umber, a round brush sharpens the features and continues to strengthen the contours of the torso. A flat bristle brush darkens the edges of the forms, while another bristle brush adds more white to the basic flesh mixture to build up the lights all over the figure. A small brush begins to define individual strands of hair. Bristle brushes start to suggest a floral background with warm strokes of cadmium orange, raw sienna, raw umber, and white, plus cooler strokes of cobalt blue, raw sienna, and white. The chair is painted with thick strokes of cobalt blue and white.

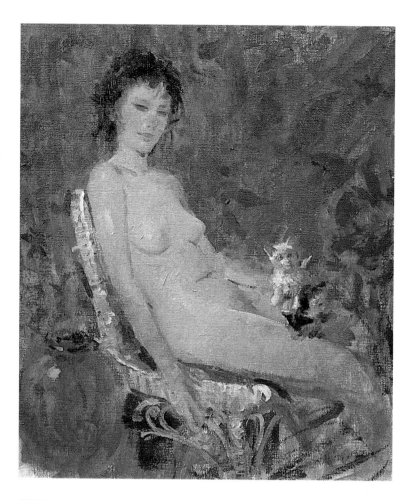

Step 6. A flat softhair brush blends the rough strokes of Step 5. The tip of a round brush adds shadow lines beneath the chin, on the neck, and beneath the breasts. The cheeks and nipples are warmed with just a little cadmium red added to the flesh mixture. The brilliant patch of red on the seat is cadmium red, alizarin crimson, a little cobalt blue, and white. The floral background grows more detailed as a small brush adds bright touches of cadmium orange, raw sienna, raw umber, and white.

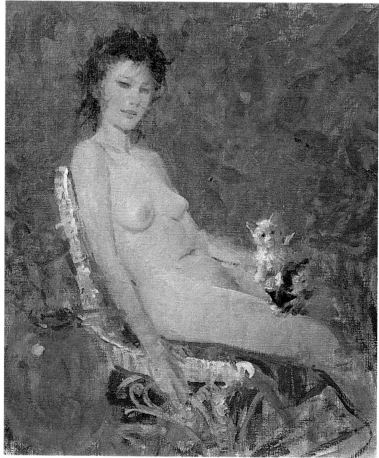

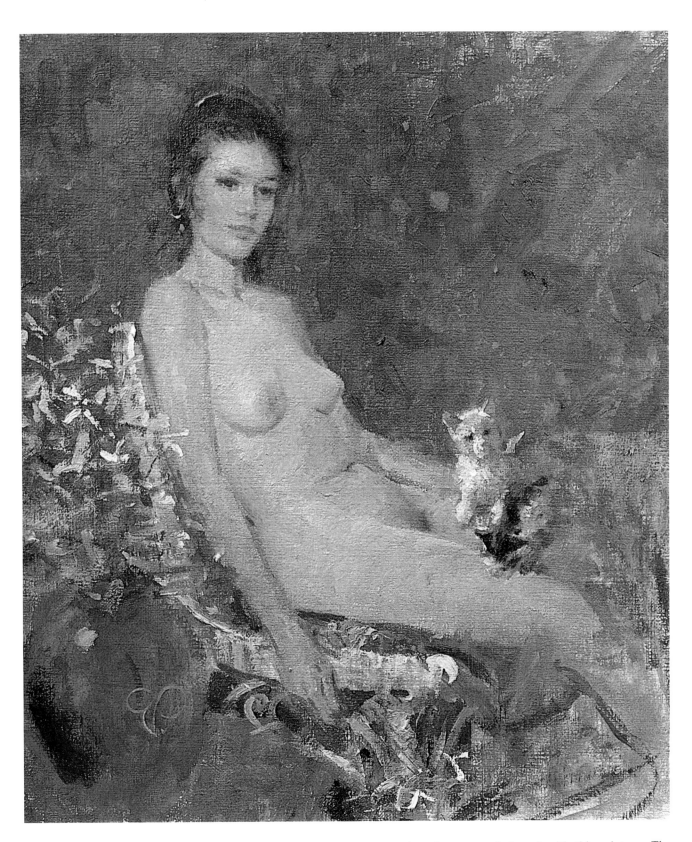

Step 7. The tip of a round brush moves over the entire figure, sharpening the edges of the forms with slender strokes of Venetian red, raw umber, raw sienna, and white. You can see where the brush has strengthened the lines of the nose and lips, the curve of the jaw, and the edges of the arm and breasts. The forearm and hand are completed with small strokes of the same mixture. The hair is carried down the sides of the face with burnt umber and ultramarine blue; the eyes and eyebrows are darkened with this mixture. The warm background tone is carried closer to the face and blended into the edges of the hair. Two tiny dabs of flesh tone suggest the ear. The patch of blue at the lower left suddenly becomes a vase as a shadow is added with a broad stroke of the hair mixture. Wildflowers are added with quick, spontaneous strokes of cobalt blue and white.

Step 1. The canvas is toned with cobalt blue and turpentine. Then the preliminary sketch is begun with a bristle brush that carries the same mixture. The brush scrubs in the dark tone of the distant trees in the upper half of the picture. The shapes of the model are blocked in with thick, straight strokes. The brush indicates a few masses of shadow. Notice that the face and most of the hair are in shadow. As always, the artist looks for alignments. The vertical line of the neck lines up with the vertical line of the inner thigh; a single diagonal line connects the shoulders; and another diagonal line connects the undersides of the buttocks.

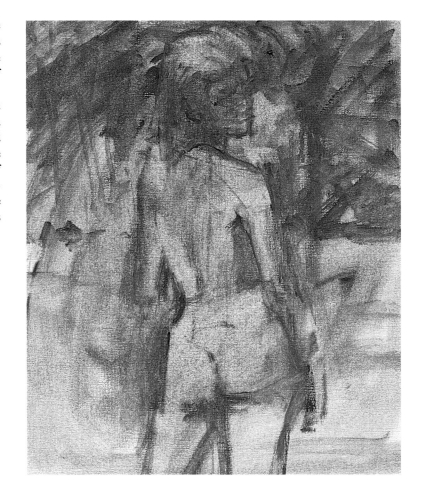

Step 2. A flat bristle brush continues to darken the trees in the upper half of the canvas and then indicates their reflections in the pond that fills the lower half of the picture. The sharp point of a round softhair brush goes over the contours of the figure, drawing them more precisely as a rag wipes away the lights and the unnecessary strokes. Most of the figure is brightly lit, but there are strong patches of shadow on the face, arms, back, and buttocks.

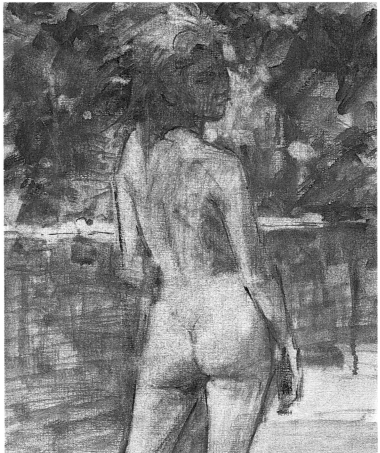

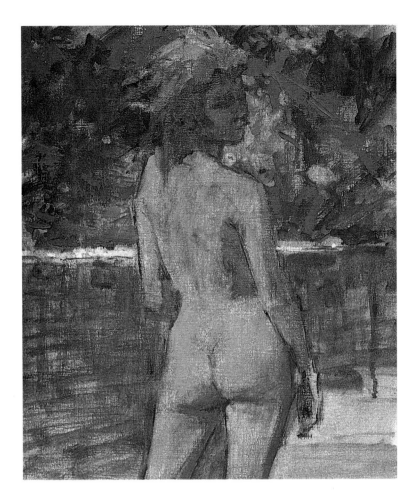

Step 3. A mixture of raw umber, cadmium orange, Venetian red, and white is lightly brushed over the shadow tone, with some of the underlying blue allowed to shine through. Then a big brush blends raw umber, yellow ochre, Venetian red, and white, and scrubs this lightly over the sunlit areas of the body, again with some of the underlying blue allowed to come through. More yellow ochre is added to the flesh mixture for the sunlit patches on the hair. Strokes of soft green are brushed into the foliage and carried downward into the reflecting surface of the water; this is a mixture of ultramarine blue, cadmium yellow, raw umber, and white. A warmer, more subdued tone is brushed around the head and over the foliage with a mixture of ultramarine blue, Venetian red, and white.

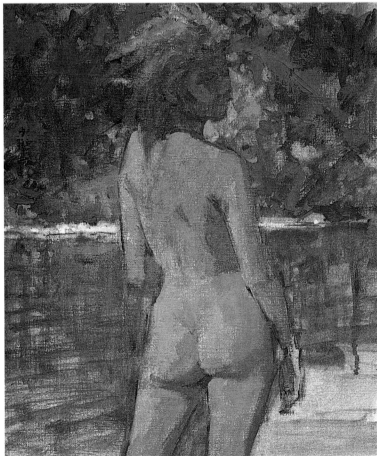

Step 4. Working with thicker paint diluted with painting medium to a creamy consistency, bristle brushes now begin to apply more solid color to the figure. The pale skin mixture is enriched with more yellow ochre and Venetian red to darken the upper back, arms, and thighs. A paler version of this mixture is carried down over the buttocks, and this mixture is cooled with a speck of cobalt blue for the halftones. Brighter, thicker color is added to the shadow areas of the face and body.

Step 5. Having covered the upper back with a darker tone, a bristle brush blends more raw umber into the shadow mixture to strengthen the darks on the back and shoulder. This darker tone is brushed into the shadow areas of the hair and carried into the face to define the features. The sunlit top of the hair is brightened with thick strokes of yellow ochre, raw umber, and white. Foliage reflections are added to the water with ultramarine blue, cadmium yellow, raw umber, and white. The patch of beach at the lower right is covered with broad strokes of Venetian red, cobalt blue, and lots of white.

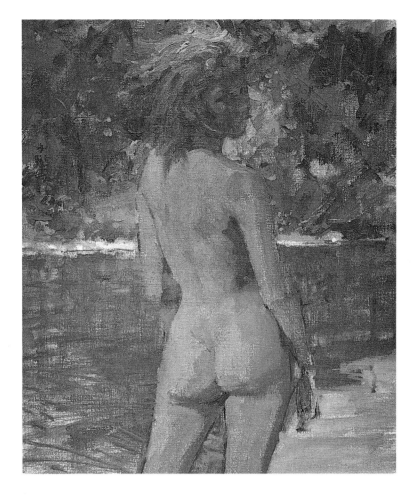

Step 6. Now a flat brush concentrates on the arms, buttocks, and thighs. Warmer, darker tones are brushed down the length of the downstretched arm and thighs, since the limbs are normally darker than the torso. A hint of darkness is added inside the crook of the bent arm. Adding more white to the pale flesh mixture, the brush begins to build up the lights on the buttocks. Notice the cool notes of cobalt blue blended into the shadows beneath the buttocks and in the halftones. The tip of a round brush continues to brighten the sunlit hair with yellow ochre, raw umber, and white, and adds some touches of light to the features with the same mixture.

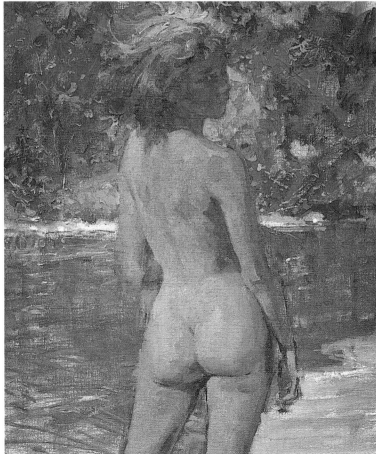

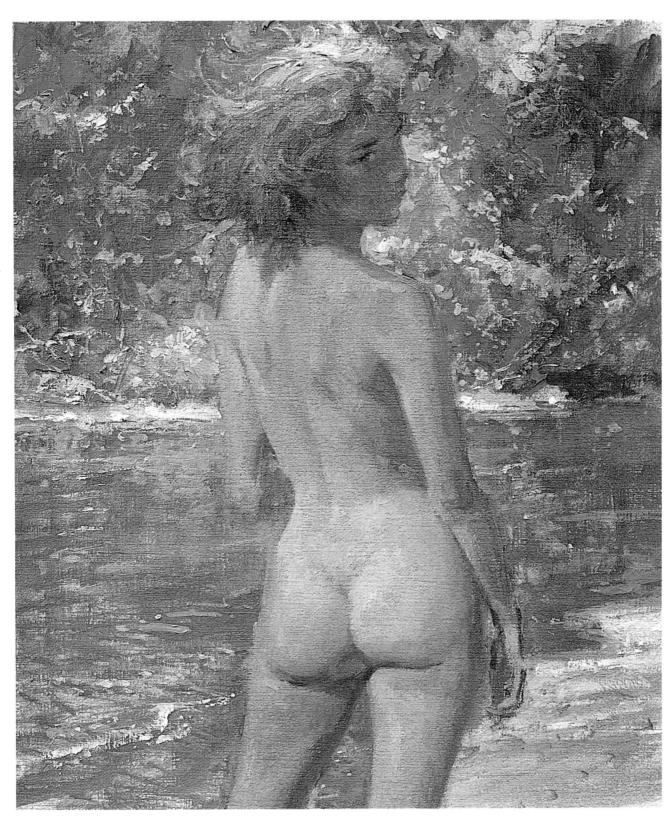

Step 7. Small flat brushes blend the lights and shadows on the back and downstretched arm, build up the lights on the back and buttocks, and darken the shadow sides of the thighs. The tip of a round brush sharpens the features, blends touches of the cadmium orange and bluish background tone into the hair, sharpens the eyes with raw umber and cobalt blue, and brightens the face with tiny touches of cadmium orange, cadmium red, and blue background color. Finally a small brush moves over the entire background, suggesting sparkling sunlight on the leaves and water with thick strokes of white tinted with cobalt blue and alizarin crimson.

Step 1. The painting surface is toned with random strokes of raw umber and turpentine. A round brush picks up a darker version of this mixture to sketch in the major lines of the figure—without making any attempt to draw the figure precisely. At this point the hair is simply a blur of tone; the arms are nothing more than diagonal lines; the upper torso is represented by two straight lines for the outer edges plus a center line that runs through the abdomen; and the lower torso is described with straight lines for the hips and thighs plus a curving stroke for the raised hip.

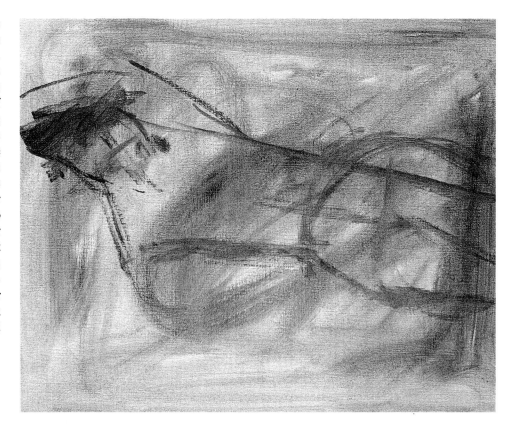

Step 2. The tip of the brush begins to draw the figure more precisely as a rag wipes away the excess lines. The face and most of the torso are in shadow, which a bristle brush scrubs in with free strokes. As the rag wipes away the lights along the upper edge of the figure, the bristle brush darkens the background to accentuate the lighted contours of the body.

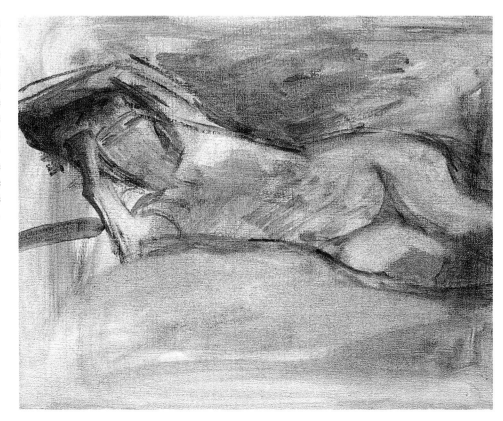

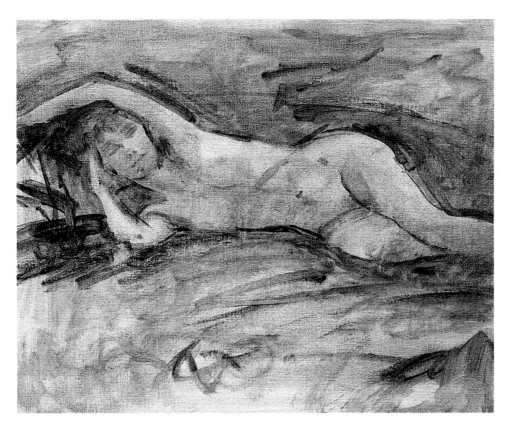

Step 3. A flat brush smoothes and blends the shadow tones on the upraised arm, face, neck, torso, and lower legs. A round brush darkens the edges of the figure and scribbles the dark tone over the background. A rag, wrapped around a fingertip, carefully wipes away the light along the edge of the torso, on the thighs, and on the arm that supports the head.

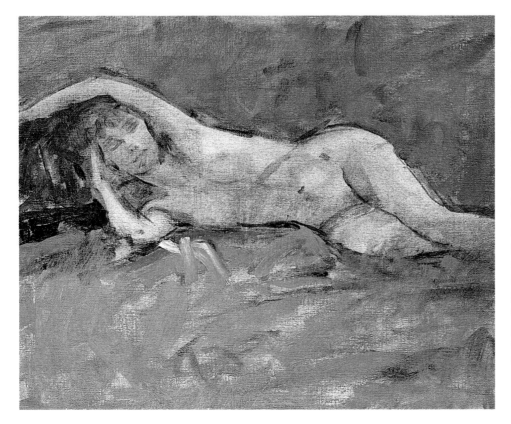

Step 4. Bristle brushes surround the figure with tones that emphasize the paler shape of the body. The background is brushed with a mixture of raw umber, raw sienna, and white. Then the brush blends cobalt blue, raw umber, raw sienna, and white into the wet undertone. The blue cushion under the model's head is indicated with strokes of cobalt blue, raw umber, and white. Alizarin crimson and more white are added to this mixture for the cool tone of the foreground. The hot color of the drapery beneath the torso is painted with rough strokes of cadmium red, yellow ochre, and white.

Step 5. The warm shadow tone on the front of the figure is painted with a bristle brush that carries a mixture of raw sienna, burnt umber, cadmium orange, and white. Notice how a bit of the cool foreground tone is blended into the midriff and abdomen. More white is added to the shadow mixture and applied in thick strokes over the lighted planes of the torso, thighs, cheek, and the arm beneath the model's head. Darker strokes of cobalt blue, raw sienna, raw umber, and white enrich the background and dramatize the lighted edge of the figure.

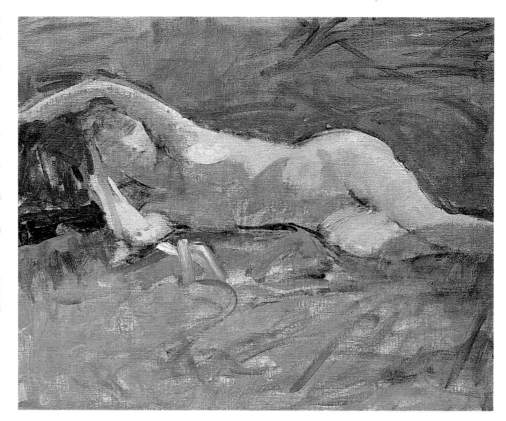

Step 6. The shadow mixture is darkened with more burnt umber, and a small brush sharpens the shadowy contours of the head, breasts, midriff, and abdomen. Adding more cadmium orange to this tone, a small bristle brush brightens the face and hair, indicates the nipples, and adds touches of warm color to the knees. Thick strokes of white tinted with flesh tone illuminate the thighs. More touches of the cool foreground mixture are blended into the shadow plane of the torso.

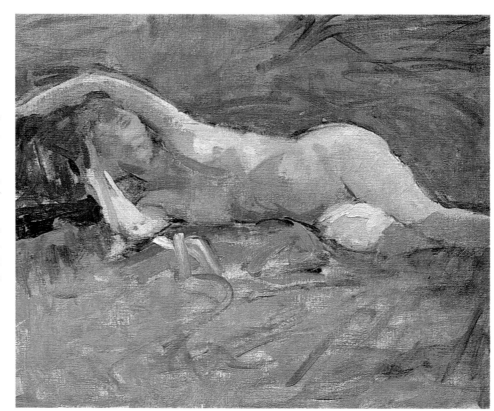

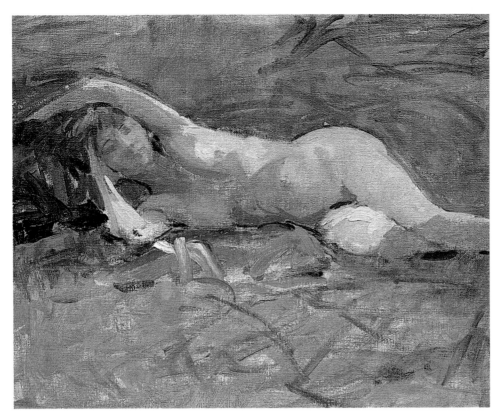

Step 7. A round brush paints the hair with crisp strokes of burnt umber, Venetian red, and raw sienna, with an occasional dark touch of cobalt blue. This mixture (with more white) darkens the eyes and the nose. A speck of cadmium red is added to this mixture to warm the cheek and the lips. The tip of the brush draws a dark line of shadow beneath the neck and places another shadow beneath the legs to anchor the figure to the ground.

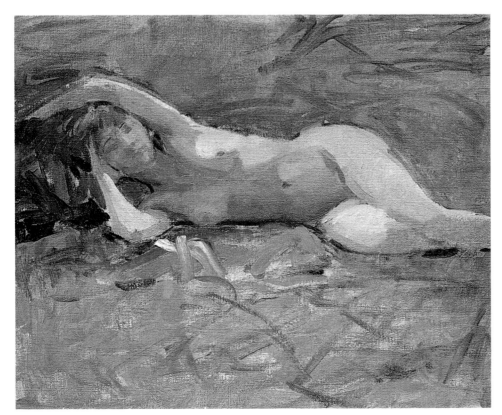

Step 8. A flat softhair brush moves down the torso, blending the tones together to make the forms look smoother and rounder. The thick touch of white on the lower thigh (see Step 7) is now blended smoothly into the surrounding color. A small bristle brush travels over the lighted contours of the torso, modifying the color with a cool mixture of white tinted with a speck of raw sienna and ultramarine blue. This strengthens the contrast between the lighted planes and the shadow planes of the body.

Step 9. The pillow beneath the model's head is brightened with thick strokes of cobalt blue, raw umber, and white. The tip of a round brush builds up the lights on the face with a pale mixture of white, ultramarine blue, and raw sienna. The tip of the brush sharpens the features and blends the shadow on the neck. A flat brush blends the light and shadow planes on the arm beneath the model's head and then continues to blend the tones on the thighs. Another blue pillow is placed on the far side of the model's legs with cobalt blue, raw umber, and white. The bright drapery is extended with cadmium red, raw sienna, and white. The foreground is covered with strokes of cobalt blue, raw umber, and white.

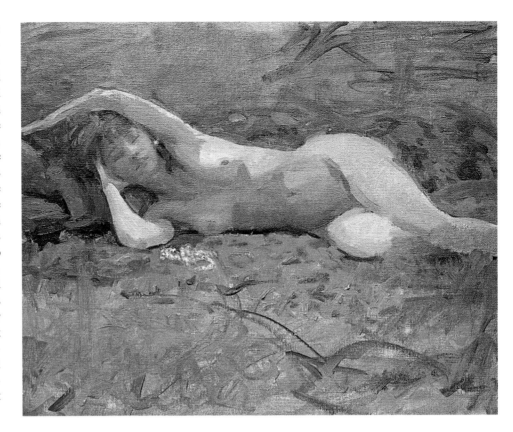

Step 10. Small flat brushes continue to build up the lights on the figure with pale strokes of white tinted with raw sienna and ultramarine blue. The lighted areas on the abdomen and thighs become brighter and cooler. The lighted edge of the figure is blended softly into the dark background. Compare the hard edge of the midriff in Step 9 with the softer edge in Step 10.

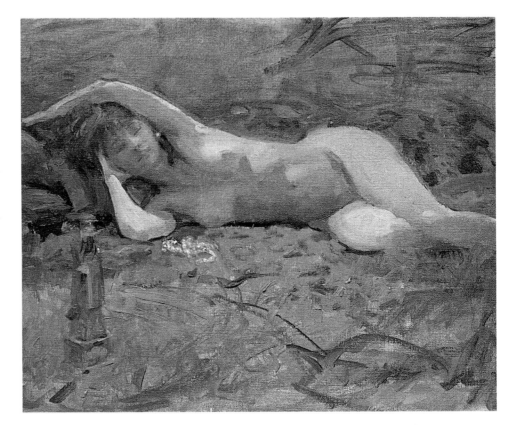

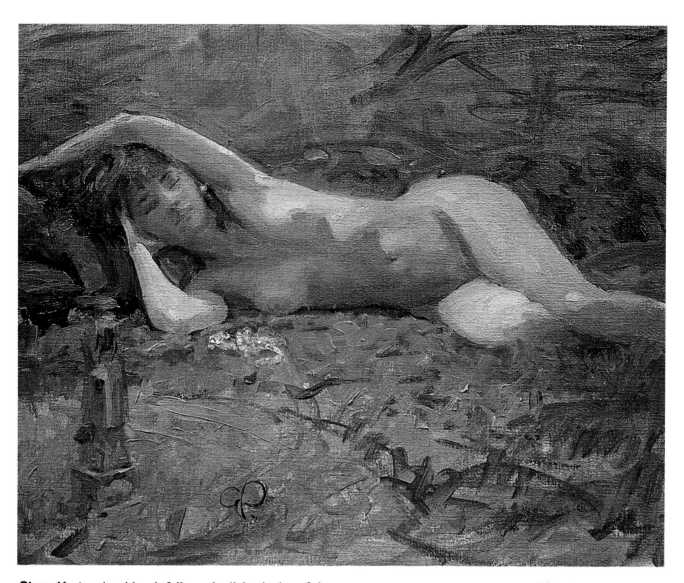

Step 11. A pointed brush follows the lighted edge of the raised arm, brightening the contour with a single, rhythmic stroke. The same brush adds highlights of pure white, tinted with a speck of raw sienna and ultramarine blue, to the lighted breast, midriff, hips, thighs, and the elbow of the arm beneath the model's head. Notice how touches of the warm drapery color are blended into the shadow areas of the torso—the breasts, midriff, and abdomen. It's worthwhile to remember that the skin can serve as a reflecting surface, picking up hints of the surrounding colors. A small, pointed brush sharpens the lines of the eyebrows and the eyelids. The dark shadow lines beneath the figure have been blended softly into the warm tone of the drapery; the lines are still there, but they are less prominent, conveying the feeling that the figure rests more solidly on the ground. This painting demonstrates how colorful a shadow can really be—and how much detail can be suggested within the shadow.

Step 1. A large bristle brush tones the canvas with ragged strokes of raw umber and turpentine. A round brush picks up the same mixture to sketch the major lines of the figure. Notice how few lines there really are. A single curving line defines the underside of the torso, traveling from the armpit down under the buttock. On the upper contour of the body, one line defines the back, while another line travels from the waist over the buttock and along the top of the thigh. A curving center line moves down the back, connecting the back of the neck, the spine, the division between the buttocks, and the underside of the thigh.

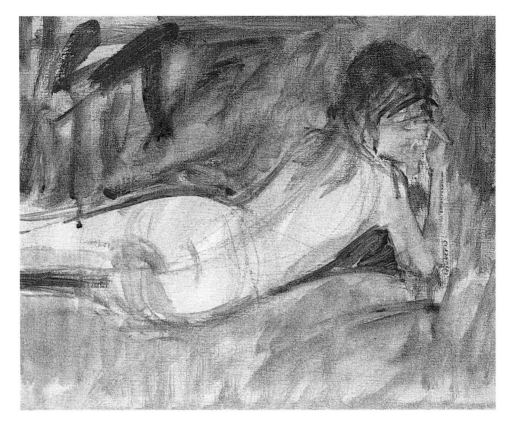

Step 2. The tip of the round brush retraces the lines of the figure more carefully, still following the original guidelines. The small brush also defines the features and hair. A flat brush blocks in the shadow tones on the face and arm, the underside of the torso, the buttocks, and the thigh. A rag wipes away the lights, and a big bristle brush darkens the foreground and background.

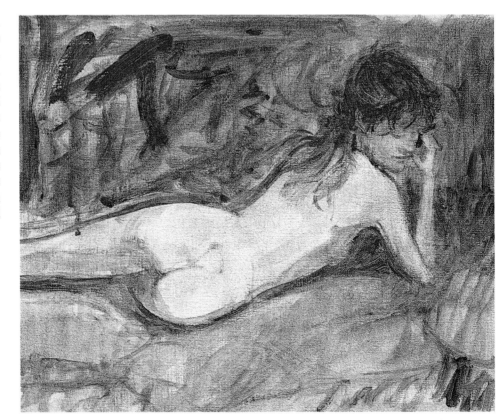

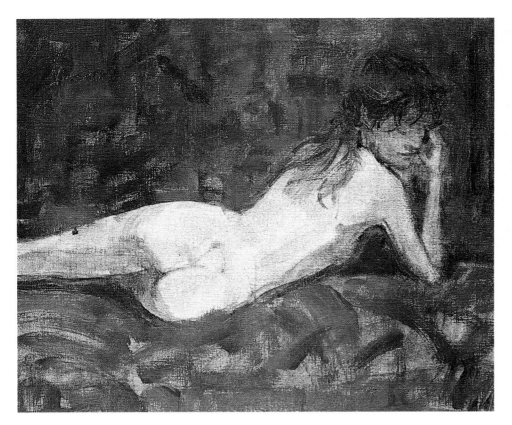

Step 3. Because the figure is essentially a pale shape surrounded by a dark background and foreground, work begins on these dark areas. The upper half of the picture is covered with broad strokes of ultramarine blue, burnt umber, viridian, and white. Just above the hip, the background is warmed with a few strokes of ultramarine blue, alizarin crimson, raw umber, and white. The subdued foreground tone is a blend of ultramarine blue, burnt umber, yellow ochre, and white. As these dark tones are carried up against the edges of the figure, the silhouette of the body can be seen more precisely—and it will be easier to mix the light and dark flesh tones.

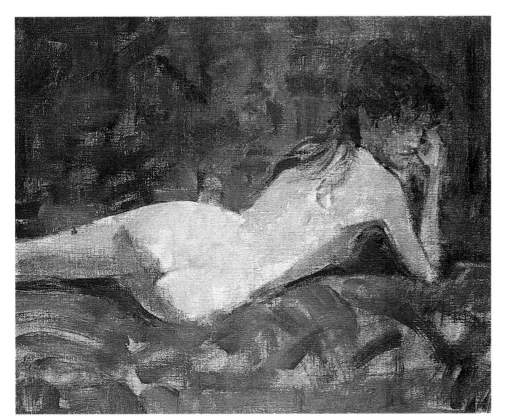

Step 4. A large bristle brush covers the few shadow areas of the torso and leg with a mixture of burnt umber, cadmium orange, yellow ochre, and white—scrubbing some of this mixture into the shadow side of the face. Then another big bristle brush covers the back with raw umber, yellow ochre, Venetian red, and lots of white. A bit more white is blended into the buttocks, while the thigh and the upper arm are painted slightly darker.

Step 5. A small bristle brush blocks in the hair with a warm, dark mixture of burnt umber, ultramarine blue, a little Venetian red, and white. The shadow side of the face is darkened with the mixture that first appeared in Step 4: burnt umber, yellow ochre, cadmium orange, and white. The pale flesh mixture is warmed with more yellow ochre and Venetian red to enrich the tone of the face and add more warm tones to the lighted areas of the back and arm. The lighted area of the face is distinctly darker than the lighted plane of the back. The upper half of the back is darkened where the hair will fall and where the spine creates a soft depression just above the waist.

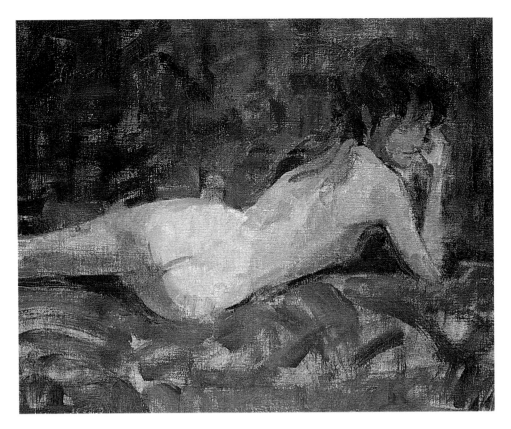

Step 6. The artist concentrates on the head with small brushes. The shadow area of the forehead and cheek are carefully shaped, and then the bright patches are placed on the forehead, cheek, nose, and chin. The tip of a small brush paints the eyes, the shadowy underside of the nose, the lips, and the individual strands of hair, some of which wander over the neck and down the back. The shadow areas of the face are burnt umber, yellow ochre, cadmium orange, and white, while the lighter areas are raw umber, yellow ochre, Venetian red, and white, with a hint of cadmium red on the cheeks and lips.

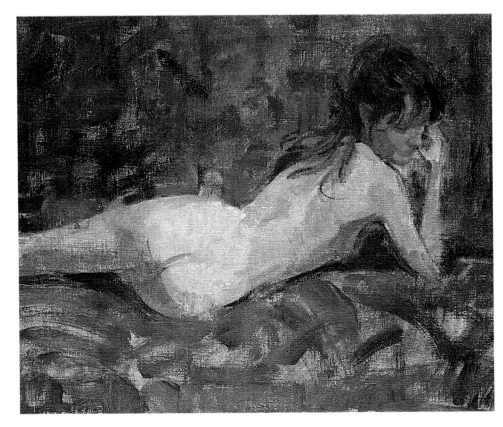

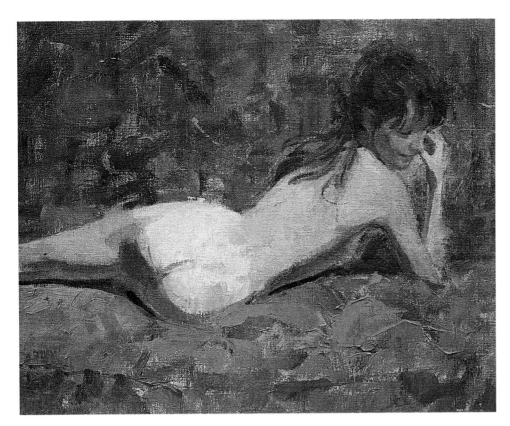

Step 7. A flat softhair brush blends the lights and shadows on the face. A round brush sharpens the eyes, mouth, and chin. A flat brush works down the back, shoulders, and upper arm, darkening and blending the tones. The thigh is also darkened and blended. Then a small bristle brush darkens the shadows under the arm, along the underside of the torso, beneath the buttocks, and along the thigh. A painting knife goes over the foreground with thick strokes of ultramarine blue, burnt umber, viridian, and white, while a bristle brush adds strokes of ultramarine blue, alizarin crimson, raw umber, and white beneath the thigh.

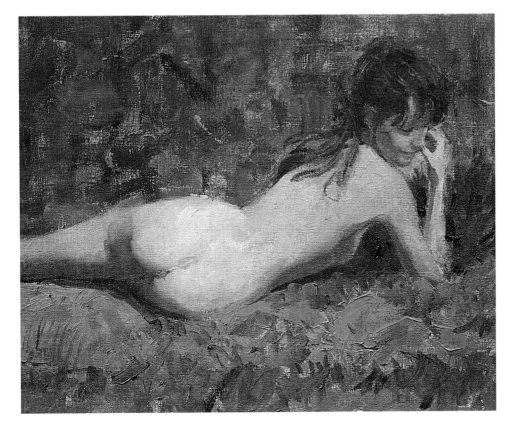

Step 8. Blending more white into the original pale skin mixture, a bristle brush builds up the lights on the buttocks, carrying a stroke into the lower back to suggest the lighted edge of the spine. Touches of white are also blended into the upper edge of the thigh, the back beneath the hair, and the shoulder area. A flat softhair brush blends the edges of the shadows where they meet the lights. This blending process produces halftones between the lights and shadows. You can see this effect most clearly on the buttocks and thigh. A bristle brush continues to build up the texture of the foreground drapery with the colors that appear in Step 7.

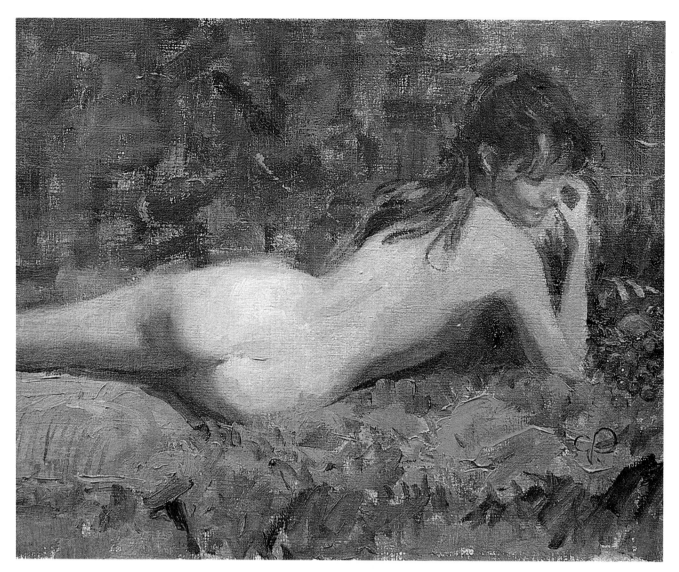

Step 9. Wandering over the dark background, a bristle brush adds occasional touches of warmth with ultramarine blue, alizarin crimson, raw umber, and white. Where the background meets the hip and thigh, a small bristle brush softens the edge of the figure, blending the flesh tone so that it merges softly with the darker tone of the background. In the same way the hair that drapes over the forehead is blended softly into the background color. Adding an extra touch of cadmium orange to the shadow mixture, a flat soft-hair brush adds more warmth to the thigh and buttocks. Thick white, straight from the tube, is tinted with minute amounts of raw umber, yellow ochre, and Venetian red; highlights of this pale, luminous tone are placed on the but- tocks, spinal area, and shoulder and then blended so softly into the surrounding flesh that they're almost invisible. A pointed brush places tiny highlights (with the same mixture) on the nose, chin, and ear. Beside the elbow a bunch of grapes is added with a small brush that carries various mix- tures of ultramarine blue, burnt umber, alizarin crimson, and white. The orange is painted with cadmium red, cad- mium orange, yellow ochre, and white. Four separate strokes of pale flesh tone suggest the fingers of the hand reaching for the grapes. The painting is completed with a few strokes of ultramarine blue, alizarin crimson, and white, for the ribbon that holds the model's hair.

Deciding the Pose. The most important thing to remember is that the pose ought to look natural. The simplest poses are usually best. If the model is standing, let her plant her feet firmly on the ground so she can hold the pose without stress; don't ask her to take a dancing pose or twist her body into some dramatic contortion that she can't possibly hold long enough to paint. A seated pose is particularly easy to hold for a long time; if the model naturally slouches or leans in one direction, let her do what's most comfortable. Of course, reclining poses are the easiest for the model because she can relax totally and hold the pose indefinitely. Whatever pose you agree upon, let the model move around until she feels stable and relaxed. Remember that what's naturally comfortable for *one* model may not be right for *another*. If the model feels right in a particular pose, she'll look right too—and your painting will reflect her sense of comfort, relaxation, and stability. If she feels awkward, your painting will look awkward. In short, although you may start out with a general idea of the kind of pose you want to paint, work along with the model to establish a pose that's most natural for her particular build and temperament.

Lighting. In most cases, you'll probably work indoors, preferably with natural light that comes from a fixed location like a window or a skylight. In the pages that follow, you'll find examples of different kinds of lighting. Move the model around your work area to see how she looks in different kinds of light. It's usually best to start out with 3/4 lighting because it's the easiest to paint. When you've painted a number of pictures in 3/4 light, then you can go on to the more complex effects of frontal lighting, back lighting, and rim lighting. Of course, if you're working with artificial light, you can let the model stay in one place and just move the light fixtures around to get the effect you want. The lighting, like the pose, ought to be as simple as possible. If you have a big window or a skylight that illuminates the whole room, that's probably all the light you need. If you're working with artificial light, don't surround the model with lighting fixtures which hit her from so many different directions that you can no longer tell the lights from the shadows. Arrange the lighting fixtures so that the rays strike her from just one direction, perhaps adding a very small lamp on the opposite side to make the shadows a bit more transparent. For artificial lighting, choose the warm light of incandescent bulbs or "warm white" fluorescent tubes; avoid the harsh, mechanical light of "cool white" fluorescent tubes.

Outdoor Light. If you can find some secluded place to paint the figure outdoors, keep in mind the same guidelines. You'll find it easiest to paint the model when the sun strikes her from one side and also from slightly in front, producing 3/4 or "form lighting." Later on, you can try placing her with the sun directly in front or directly behind to produce frontal or back lighting. You'll get the best outdoor lighting effects in the early morning, mid-morning, and middle or late afternoon—rather than midday, when the sun is directly above the model, creating harsh lights and shadows. (Besides, the model can get a nasty burn from the midday sun.) And don't neglect the soft, diffused light of an overcast day, which can be particularly delicate and beautiful.

Background and Props. Whether you're painting the figure indoors or outdoors, the model will be surrounded by the shapes and colors of walls, floors, furniture, trees, ground, or sky. These background elements are an important part of the picture. Pay careful attention to them; choose colors that flatter the model's skin and hair; but avoid any distracting details that might divert attention from the model. The cool tone of a blue wall or drape, or perhaps a mass of green trees, will heighten the warmth of the model's skin. But paint these with broad strokes that minimize the pattern in the wallpaper, the weave of the drape, or the detail of the foliage. Work in broad strokes that simplify the background to a mass of color. Save your more precise, intricate brushwork for the figure itself. Look for backgrounds that will provide flattering contrasts with the figure. A dark background tone will accentuate the light falling on the figure. A pale background will accentuate the shadows on the figure—particularly if the figure is lit from behind, with most of the front in shadow. Keep the background colors more subdued than the figure, so the flesh looks luminous and vital. If the model sits on a chair or reclines on a couch, choose the simplest furniture and avoid upholstery with an elaborate pattern. Professional figure painters often collect inexpensive fabrics (in flat, simple colors) to create various background colors. The model can sit or recline on an old blanket or bedspread. Or the fabric can be draped behind the model on a folding screen.

Some Do's and Don'ts. Avoid "glamor" poses that exaggerate the model's charms like a publicity photograph of a star. Such paintings tend to look like caricatures. For the same reason, don't exaggerate details like eyelashes, ruby lips, pink cheeks, painted fingernails or toenails. In fact, it's usually best for the model to wear a minimum of makeup. In general, avoid *all* kinds of exaggeration. A nude figure in a natural, relaxed, harmonious pose is *inherently* beautiful.

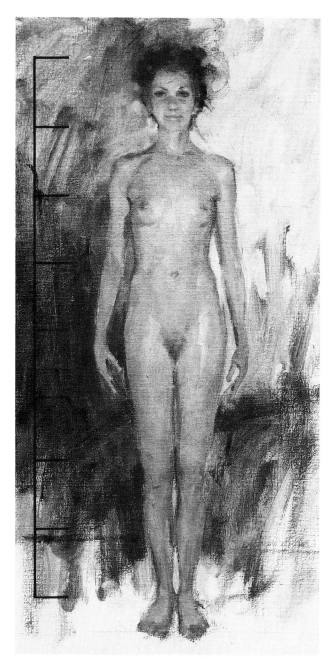

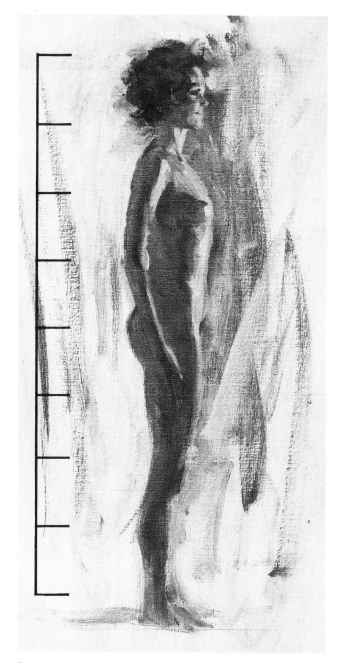

Front View. Although figures vary, it's helpful to memorize the proportions of an "ideal" figure and keep these proportions in mind as you paint. The most convenient method is to use the head as the unit of measurement. Painters generally visualize a figure which is eight heads tall. The torso is approximately three heads tall from the chin to the crotch, divided into thirds at the nipples and navel. The upper leg is two heads tall, and so is the lower leg. At the widest points—the shoulders and hips—the torso measures about two head lengths. It's obvious that not every model will have these "ideal" proportions. Nor will every pose be as easy to measure as this standing figure. But if you stay *reasonably* close to these measurements, making some adaptations to suit the particular build of the model, the proportions of your figures will always be convincing.

Side View. It's also important to remember the alignments of the various forms of the figure. The lower edge of the breast is halfway down the upper arm, while the elbow usually aligns with the waist. Comparing the front and side views, you can see that the wrist aligns with the crotch and with the widest points of the hips.

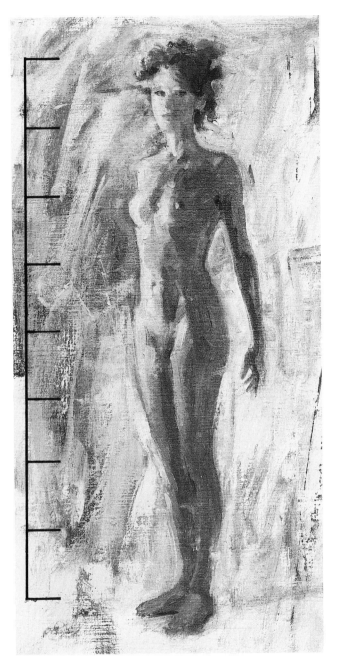

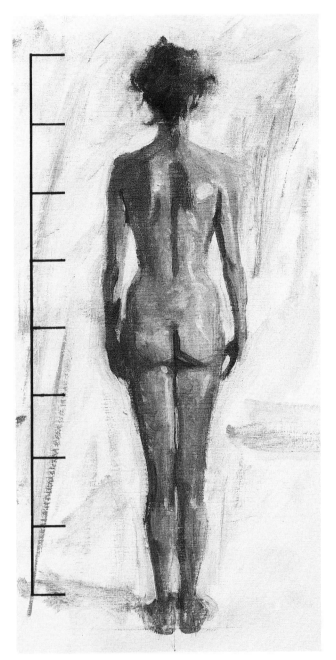

3/4 View. As the model turns, certain proportions will remain the same, while others will obviously change. In this 3/4 view, the model is still roughly eight heads tall; the torso is three heads tall; and the legs are four heads tall, which means two head lengths for the upper legs and two head lengths for the lower legs. The elbow still aligns with the waist, while the wrist still aligns with the crotch and the widest points of the hips. In this view, however, the figure is less than two heads wide at the shoulders and the hips. The foot, by the way, is usually just a bit less than one head length from toe to heel.

Back View. Seen from behind the figure displays essentially the same proportions as the front view. The figure is still eight heads tall, of course, and about two heads wide at the shoulders and at the widest points of the hips. Notice that the hips are widest just above the lower line of the buttocks. It's always useful to look for other alignments when you draw or paint the figure. For example, in this view the points of the shoulders line up with the wide points of the hips, while the armpits line up with the bulges of the hips just below the waist.

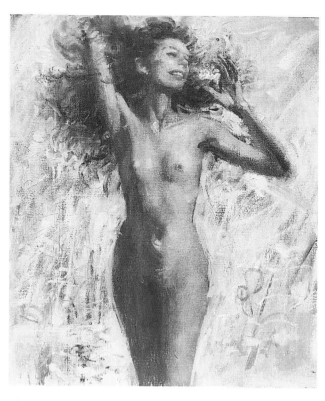

3/4 Lighting. The light illuminates one side of the figure and part of the front, throwing the other side into shadow. The light source is also slightly above, illuminating the tops of such forms as the head and arms.

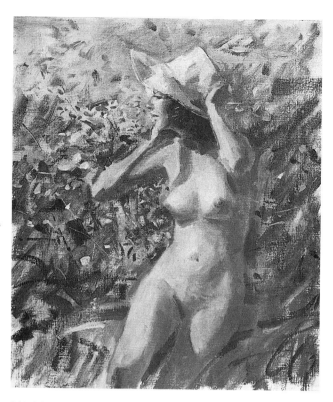

3/4 Lighting. Now the figure turns slightly toward the light. In this example of 3/4 lighting, most of the figure is illuminated, but there are still strong darks on the shadow sides of the forms.

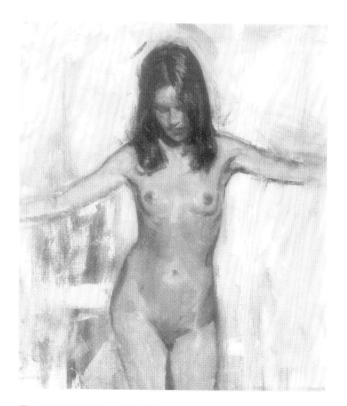

Frontal Lighting. In this type of lighting the entire front of the figure is flooded with light. There are no clearly defined masses of light and shadow. Instead there are simply shadowy edges around the forms.

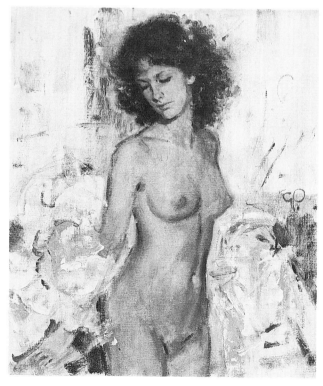

Frontal Lighting. The figure turns, but the forms are still flooded with light, and the strongest darks are just around the edges. A bit more darkness appears on the abdomen where the form curves away from the light.

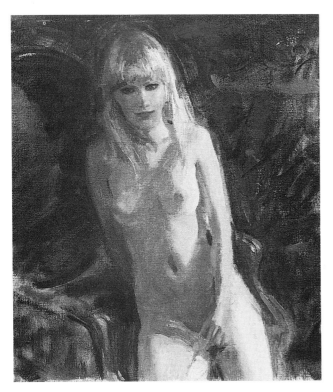

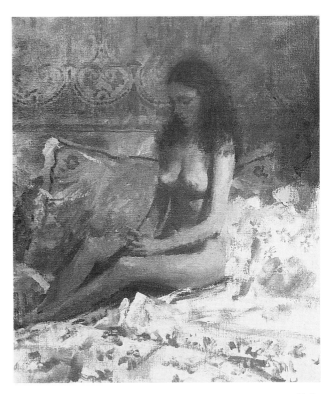

Side Lighting. When the light source is to one side of the figure, there's a clear division between light and shadow. In this frontal view of the figure, the sides of the forms are brightly lit, and the rest is in shadow.

Side Lighting. As the figure turns away from the light source, there are still bright patches of light on one arm, the breasts, and one thigh, but the rest of the figure (including the head) grows dark.

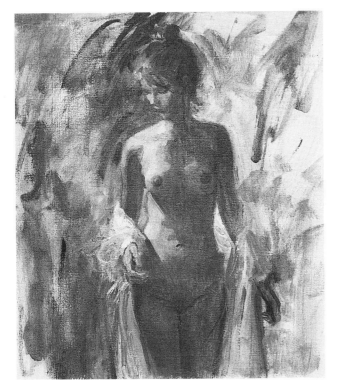

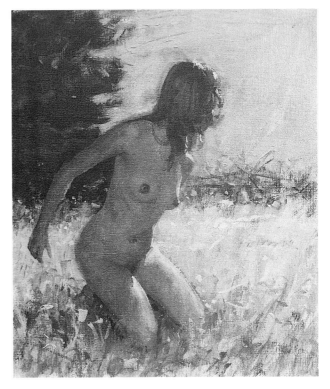

Rim Lighting. Again the light source is behind the model. Most of the figure is in shadow. A bit of light creeps around the edge to create an illuminated ''rim'' on the hair, shoulder, breast, abdomen, and thighs.

Rim Lighting. The light source is *behind* the figure and slightly above, spilling just a bit of light over one edge of the torso, but leaving most of the figure in shadow.

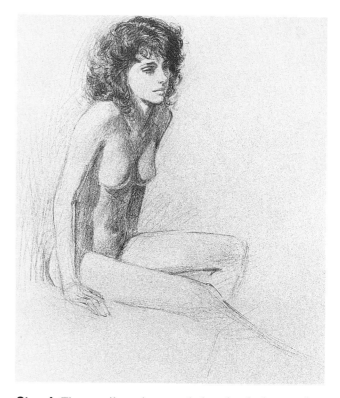

Step 1. The pencil moves lightly over the paper, tracing the contours of the forms with curving, rhythmic strokes. At times the pencil redraws the same contour several times to get the shape right.

Step 2. Pale, parallel lines fill in the dark shapes on the shadow sides of the forms as well as the dark mass of the hair. This is very much like blocking in the dark areas of a painting with broad brushstrokes.

Step 3. Pressing a bit harder the pencil moves back and forth to strengthen the darks. The pencil begins to define the shapes of the hair and such details as the features, nipples, and navel.

Step 4. The pencil continues to darken the shadows and retraces the contours with firm lines—as a kneaded rubber (putty rubber) eraser removes excess lines. The point picks out individual locks of hair and sharpens the features.

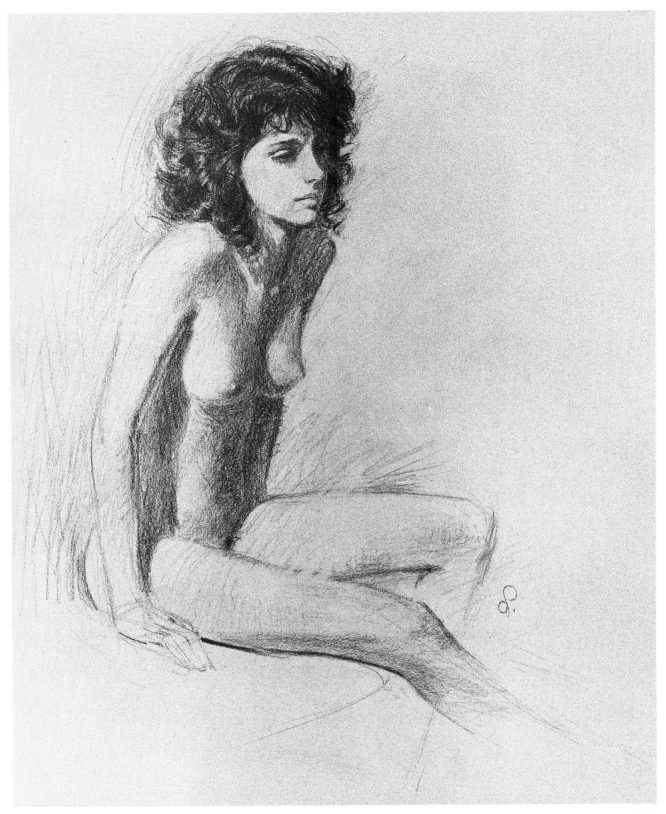

Step 5. Holding the pencil at an angle so that the side of the lead strikes the paper, the artist strengthens the darks with firm, parallel lines which you can see most clearly on the shoulder and on the torso beneath the arm. Pressing more lightly and still working with parallel lines, the pencil defines the halftones, which are most evident on the forearm and the thighs. Crisp, dark lines made with the point of the pencil define individual locks of hair, strengthen the features, and add a line of shadow where the thigh rests on the model stand. A few strokes curve around the edges of the figure to suggest the background.

Step 1. A stick of natural charcoal glides lightly over the textured surface of a sheet of charcoal paper, suggesting the shapes of the figure with a minimum number of lines. The charcoal stick accentuates the relaxed rhythm of the figure by seeking out connecting lines: the line of the raised thigh flows into the waist, while the lines of the outstretched arm flow into the line of the outstretched thigh. A few broad strokes, made by holding the charcoal stick at an angle so that the side touches the paper, suggest the two strongest darks—the hair and the shadow on the upraised thigh.

Step 2. The artist continues to hold the charcoal stick at an angle to the paper, pressing hard to darken the hair, then pressing more lightly to darken the upraised thigh with parallel strokes. Long, parallel strokes begin to define the tones on the torso, arm, and outstretched leg. The side of the charcoal is moved lightly around the figure to suggest a background tone.

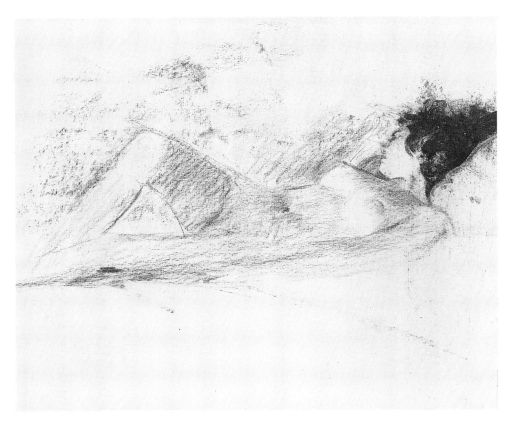

Step 3. The shape of the hair is darkened and more precisely defined with firm strokes. Then the charcoal stick gradually moves down the body, suggesting the features, darkening the shadows on the neck and chest, and defining the contours of the breasts and the midriff.

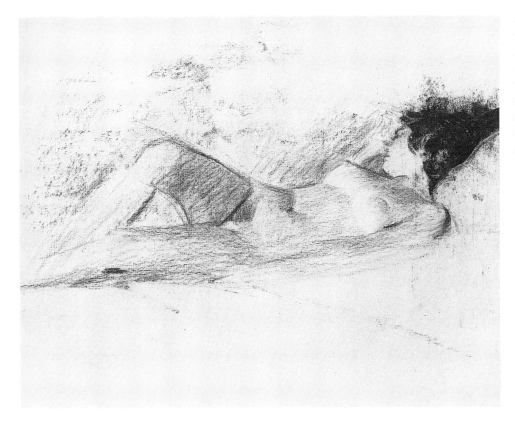

Step 4. The dark patches on the abdomen and both thighs are strengthened with parallel strokes. Then the sharp tip of the charcoal stick defines the contours of the upraised thigh and places dark lines of shadow at the shoulder and armpit.

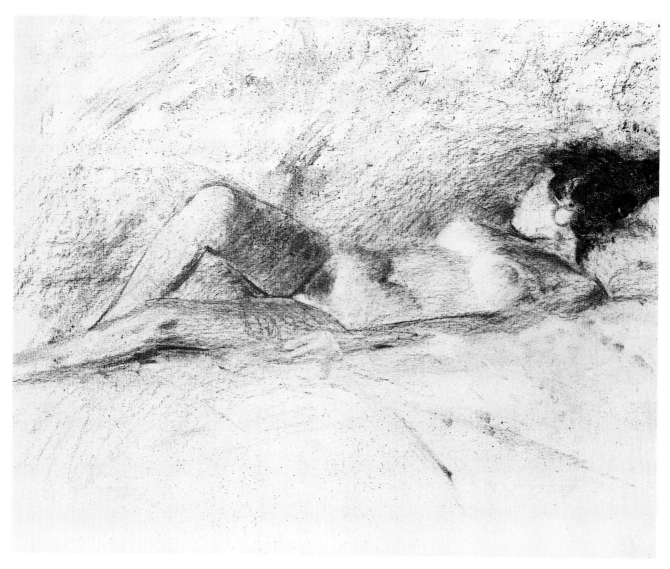

Step 5. The charcoal stick continues to sharpen the contours of the forms and darken the shadow areas. The thighs are darkened still further, and the tip of the charcoal stick defines the contours of the knees and lower legs. Working back up the figure, the charcoal strengthens the shadows on the abdomen, outstretched arm, chest, and shoulder. A crisp line defines the edge of the forearm. The lightstruck hand is "drawn" with strokes of the kneaded rubber eraser; the rubber is as plastic as clay and is squeezed to a point, which then removes small bands of tone to suggest the fingers. The charcoal moves lightly over the background to suggest more tone around the edges of the figure.

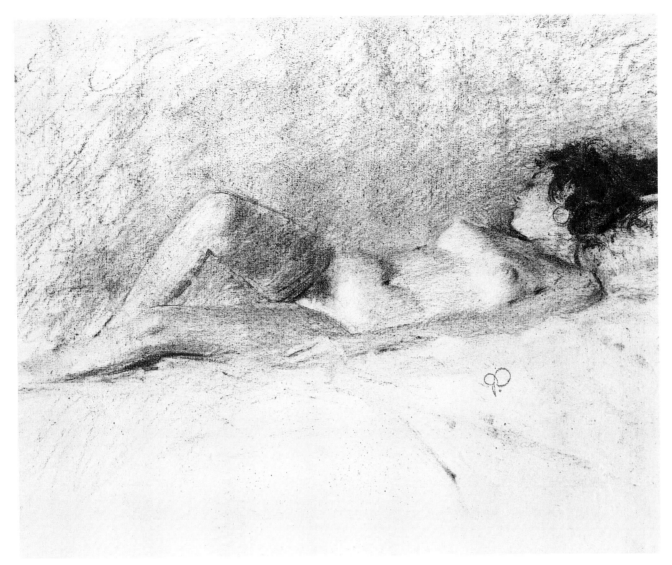

Step 6. Natural charcoal handles very much like oil paint—the tones can be smudged with a fingertip just as you'd blend wet paint with a brush. A fingertip lightly blends the tones on the chest, arm, abdomen, and thighs, not pressing hard enough to obliterate the strokes. Now these tones grow smoother and lighter. The kneaded rubber eraser is pressed gently against the paper and then pulled away to lighten the face, breasts, lower abdomen, and upraised knee. The side of the charcoal darkens the background a bit more to accentuate the lighter shapes of the figure. Then the last touches are added with the tip of the charcoal stick, which can be sharpened by rubbing it against a piece of sandpaper or any rough piece of paper. Dark lines define the profile of the head and suggest the features. The last few dark touches pick out individual locks of hair, darken the nipples and the navel, and sharpen the shadow line of a single finger. Notice how a few casual strokes in the foreground suggest the drapery on which the model is lying.

Step 1. Black chalk moves lightly over the gray paper, defining the contours. Diagonal guidelines align the shoulders and hips. Vertical and horizontal guidelines also aid in placing the features.

Step 2. The contours of the back and the underside of the thigh are defined by surrounding them with a dark background tone. A stick of white chalk begins to cover the lighted face and shoulders.

Step 3. The white chalk covers all the lighted areas, leaving the gray paper to suggest halftones. The black chalk starts to suggest the darks on the figure and also strengthens the darks of the background.

Step 4. The black chalk surrounds the figure with dark strokes that accentuate the lighted contours. Then the black chalk works on the darks within the figure, darkening the hat and sharpening the features.

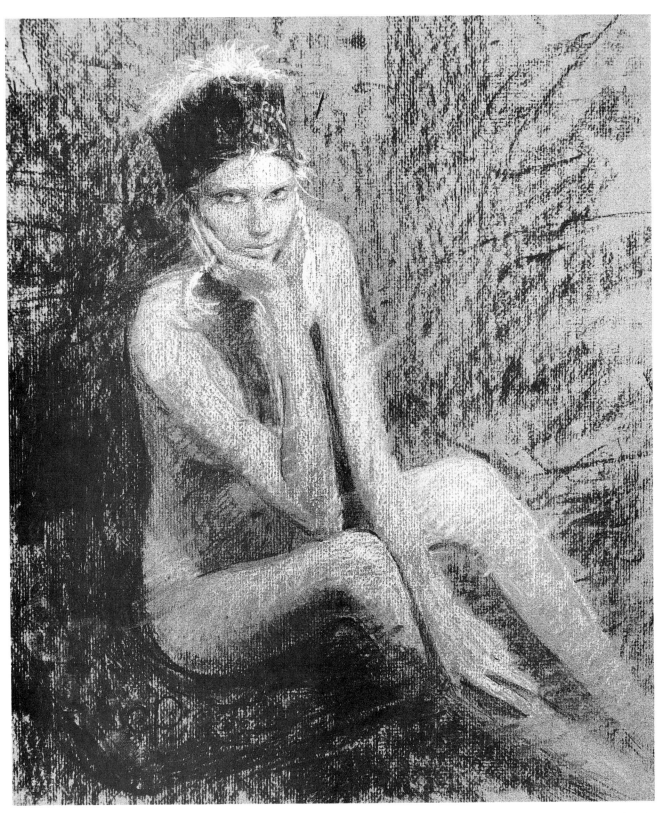

Step 5. Firm strokes of both chalks solidify the darks within the figure: the cast shadow on the chest, the shadow on the abdomen, the small patch of dark on the far thigh, and the dark underside of the near leg. Dark lines are added very selectively, sharpening the features, the fingers, and just a few dark contours of the arms and legs. A shadow is added beneath the lower hand. The background is filled with more tone, and strokes of white chalk finish the drawing by strengthening the lights, particularly on the shoulders, upper arms, thighs, and knees.

Step 1. An oil sketch is like a highly simplified oil painting. The canvas is toned with a rag that carries tube color and lots of turpentine. Then the tip of a round brush quickly sketches the shapes of the figure. The sketch emphasizes proportions and visualizes the forms as simply as possible. As you can see, the artist isn't concerned with precise drawing—the shapes will be refined as the painting progresses.

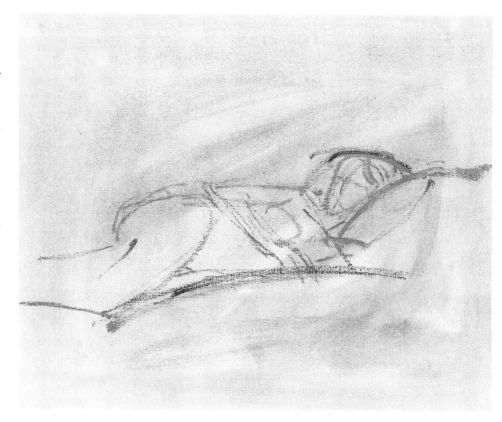

Step 2. Still working with tube color, but with much less turpentine, a small bristle brush locks in the dark masses of the shadows. At this point the painting hardly looks like a human figure, but the artist knows that if he gets the shapes of the shadows right, the figure will turn out right too.

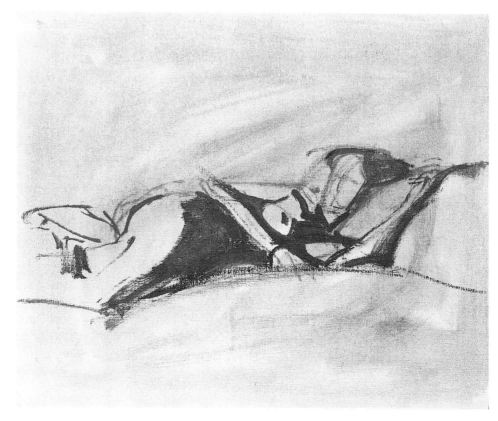

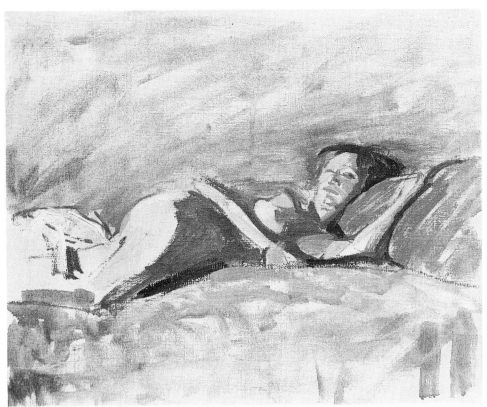

Step 3. A big bristle brush rapidly covers the lighted areas of the figure with a pale tone and brushes some of this tone into the shadows. A big brush darkens the background and the bed. Then a small bristle brush darkens the hair and adds strokes of shadow where the head and body touch the bed. The tip of a round brush adds a few strokes to suggest the features. Now all that rough brushwork begins to look like a figure.

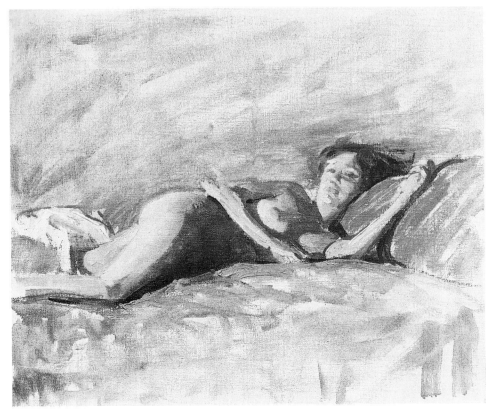

Step 4. A flat softhair brush starts to blend the lights and shadows, making the shapes seem smoother and more lifelike. Thick touches of pale color build up the lights on the head, breast, arms, and thigh. The tip of a round brush adds some dark lines of shadow to the figure and then defines the features more sharply.

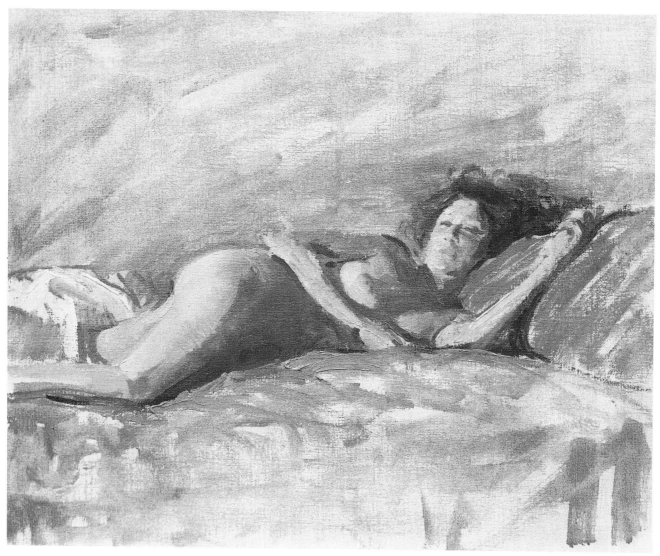

Step 5. The final touches are added with the tip of a round brush. The brush picks out a few ragged locks of hair and then sharpens the darks of the eyes, the nose, the chin, and the nipple. A single dark line of shadow sharpens the curve of the upraised shoulder. The entire oil sketch is painted with mixtures of ivory black and titanium white tube color, diluted only with turpentine. Much of the paint is as thin and washy as watercolor. The brushwork is broad and rapid. There are practically no small brushstrokes except for the few precise touches that define the features. The purpose of the oil sketch is to capture the shapes of the lights and shadows, the pose, and the mood. It's often worthwhile to make such an oil sketch as a preliminary study for a larger painting that will be executed more slowly and deliberately. It's also good experience, however, to make lots of small oil sketches in order to learn how to visualize lights and shadows as simply as possible.